ATCHAFALAYA AUTUMN

1st Printing
(October 1995)

Greg Guirard

Text and Photographs by
GREG GUIRARD

ATCHAFALAYA AUTUMN

Author, Photographer: Greg Guirard

Typing and transcription
 from tapes: Sammi Karkkainen

Typing, final manuscript: Johanna Silverman

Book design and layout: Greg Guirard

Publisher: Greg Guirard

Editing and proofing assistance: Bernard Boudreaux
 Johanna Silverman

Coordination with printer: Paula Finkle

First printing: October 1995
ISBN: 0-9624778-3-4

Typesetting and layout: Holly McGregor Carruth, *Cablecast Magazine*,
 Baton Rouge , LA
Printing: Champagne Fine Printing and Lithographing, Houston TX

This book is printed on recycled paper, thanks to financial
assistance provided by Ken Burns of Walpole, NH,
and an anonymous friend from Lafayette, LA.

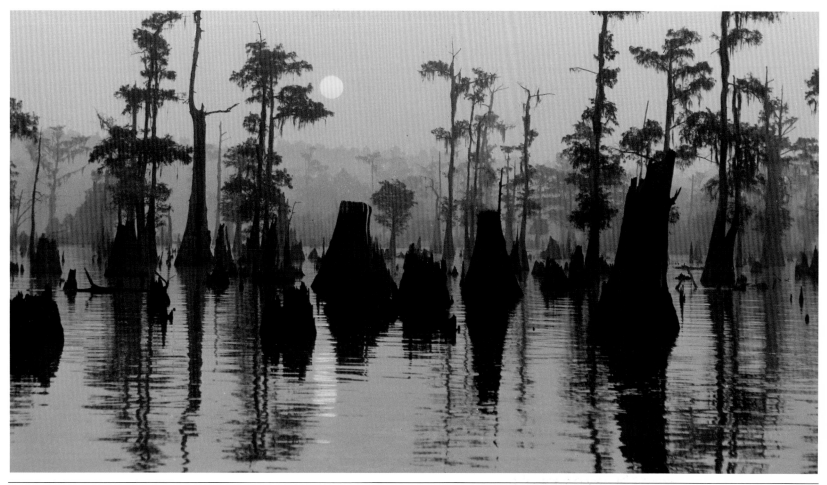

Sunrise with Cypress Stumps and Trees near Bayou Benoit – October 1979

The title of this book is *Atchafalaya Autumn* because that time of the year is my favorite and because most of the photographs I've chosen to use here are ones that were made in October, November, and December over the past six or seven years.

Thoreau said, "I went to the woods because I wished to live deliberately...," and from the first time I read that line, I wanted to understand clearly what it meant. I wanted to live deliberately, and I still do. This book is largely a result of my attempt to return to the woods of my childhood, the

Atchafalaya Basin of my youth. I was bound to fail, of course, since that young boy, and that place and time are gone now, but I have recorded the search in photographs and in journal entries, each entry corresponding to one of the times that I spent days and nights in camps and house-boats in the Atchafalaya Basin, not in chronological order.

I often wonder whether there's any real significance in what I do—Am I some kind of *Nouveau* Thoreau, or just an aging swamp/nature photographer trying to record on film one of the last nearly unspoiled semi-wild environments in the lower 48 states? For what purpose, I sometimes

wonder. My first book of color photographs, as one reviewer pointed out, was heavily crepuscular. Well, this one will be even more crepuscular–the magic hour excites me. Sunrise equals hope, rebirth, new life. Sunset equals rest, the end of things, death, or at least sleep.

I have no philosophy to offer, at least none that I can adequately express. Perhaps I'm no Thoreau at all, in any sense. I have only experiences to describe, my thoughts and feelings to record on paper, images of the world around me to record on film. I mistrust theories, conclusions, often even logic. I only record observations, impressions, the light of the sun on things whose form and texture and arrangement please me.

I've begun slowly, cautiously to let myself become "focused," to experience a small sense of peace of mind, to stop going off in all directions at once, to slow down. I look to Thoreau for encouragement in this work, this approach to life. Sometimes I speak to him: "Henry David," I say aloud, "I'm tryin' to simplify, but it's not easy..."

I remember having been on the river one February day in 1993, at the home of then 93-year-old Myrtle Bigler, whom I visit regularly. I had gone there to finish removing the residue of Hurricane Andrew from her yard. I greeted Myrtle and drank a cup of coffee with her; then I returned to the river bank to get my tools. Looking down into my boat was a sort of revelation: There I saw two chain saws, several crawfish traps, three tripods, two axes, four camera cases, and the notebook in which I write my thoughts, observations and experiences. It made me wonder who I am.

There is no place on earth where I feel more at home than in the great Atchafalaya Basin of South Central Louisiana. I was not always a photographer, but I feel that I have always had the photographer's eye for beauty and composition. At the age of twelve I began pestering my grandfather to let me use his old fold-out Kodak, so that I could record the world around me and show it to others. There is an awe-inspiring and mysterious beauty in the swamps and rivers, and there is an equally striking truth and beauty in the faces and the lives of the people who live and work in the Basin. It has been my goal, for many years, to capture and record the essence of the place and the people.

I use the word "record" because it is what I mean to say. I do not see the photographer as an artist, a creator, but as a careful and skillful recorder of the world he or she sees. I would not deny that there is art in a well-made photograph of the weather-worn face and bright eyes of an old fisherman, or in the spectacular light and color of a sunrise in the swamp. But that art is what the viewer sees in a good photograph. It is not something that was created inside the struggling heart and soul of the photographer, as is the case with true art. In addition, I do not manipulate images or use filters of any kind; I photograph people and places as I see them.

Through the years I have worked as an English instructor, a farmer and cattleman, a carpenter and furniture maker, a saw-mill worker, a crew-boat driver, a crawfisherman, and an actor and technical advisor for film production companies. Now I am primarily a photographer and writer, and though I have had no formal training in either area, I feel more satisfied and fulfilled by my present work than by anything else I have done in the past.

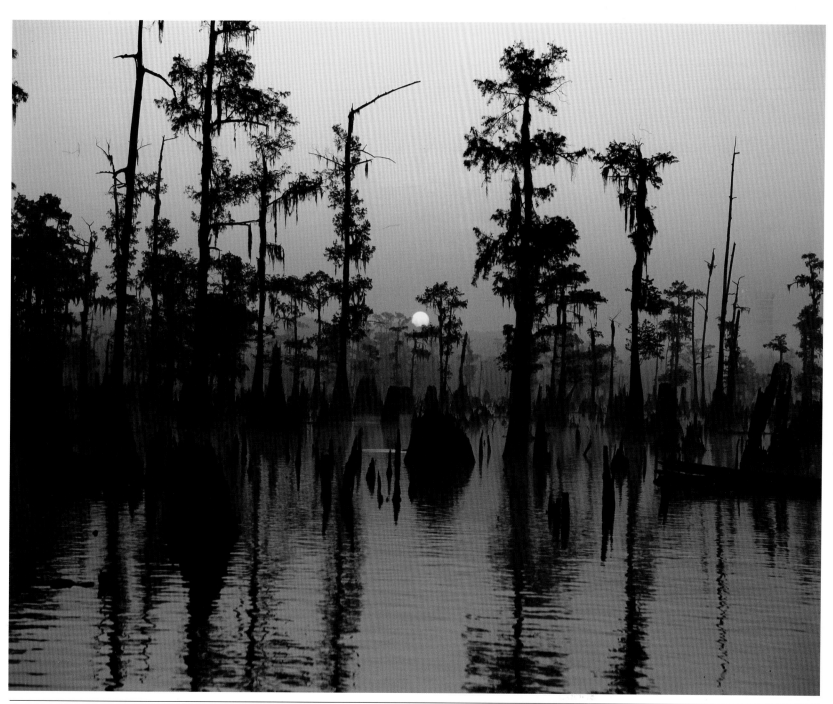

October Sunrise in the Cocodrie Swamp – 1987

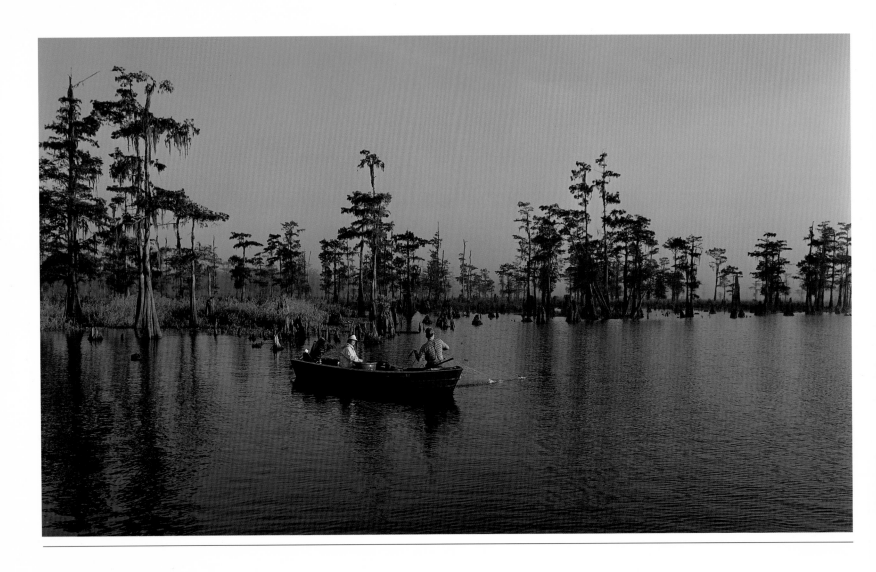

ACKNOWLEDGEMENT OF SPONSORSHIP

I wish to express my deepest gratitude to Matt Stuller and to acknowledge the generous assistance he provided in the production of this book.

Matt Stuller knows the Atchafalaya Basin well, having fished and hunted there on many occasions with his father, Dr. Gilbert Stuller.

Without Matt Stuller's support this book would not be what it is.

Greg Guirard

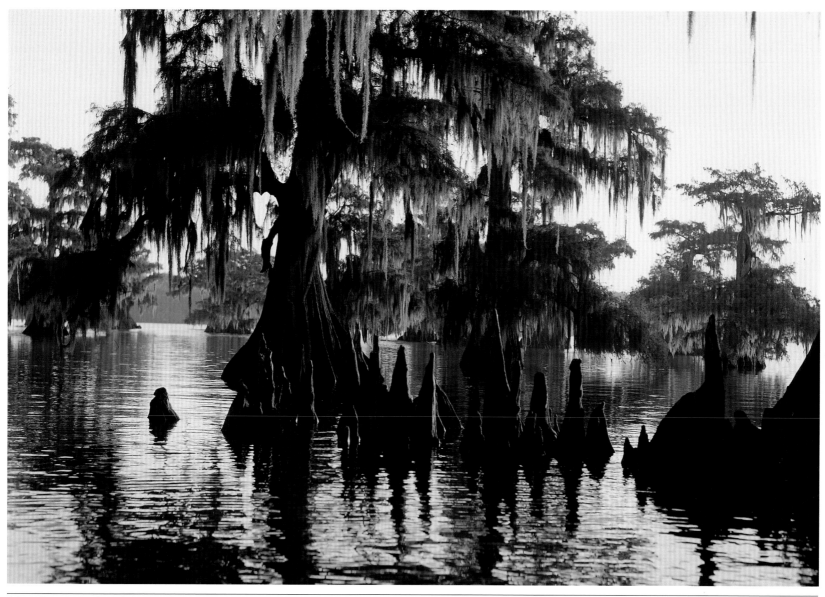

Morning at Lake Fausse Pointe – October 1987

Our life is frittered away by detail. An honest man has hardly need to count more than his ten fingers, or in extreme cases he may add his ten toes, and lump the rest. Simplicity, simplicity, simplicity! I say, let your affairs be as two or three, and not a hundred or a thousand; instead of a million count half a dozen, and keep your accounts on your thumb-nail....Simplify, simplify....

Henry David Thoreau – 1854

CAMP ON ATCHAFALAYA RIVER – MARCH 29, 1994 –
6 P.M.

Sometimes I find myself wondering how to understand and express the real meaning of wilderness, of unspoiled nature. Americans flock to the seashores and beaches, to the mountains and rivers, to the big woods, the state and national parks, even to the marshes and the swamps–anywhere that the natural world predominates over the world we've created and developed, anywhere wild and peaceful and beautiful. And we find ourselves to be refreshed; we feel less stress and tension; we begin to relax and have a sense of well-being–we begin to *live*.

But for most people, it's just a visit, a short vacation, and they find themselves reluctant to return to the world our society has created and developed–the cities, the highways, the airports, the buildings, the offices.

Our parks are overcrowded, campsites are full, walking trails are not so peaceful and isolated anymore. Beaches are crowded and there are fewer and fewer places in our country where we can go and feel that we are standing on a piece of ground where no-one else has ever stood, at least no-one in modern times. One of the fishermen I interviewed for my *Cajun Families of the Atchafalaya* book said: "They don't have a place in the Basin now where someone hasn't been. You see people now where you never used to see any before." It's a culture that needs to be protected here in South Louisiana, as well as an environment.

Yet we continue to overpopulate, to overdevelop and to build all the things we build, and in so doing we continue to destroy the natural things that were there before we invaded. And when we begin to lose some natural place, because we have been unwise in our ways of altering the world we live in, we forget its value. We consistently underestimate its role in our lives. We neglect its needs, even though it is we who have made its existence precarious.

We assume that nature can take care of itself, that it can renew itself somehow, in spite of our foolish and wasteful attitudes and activities. We fail to realize that its needs are our needs. We can justify and rationalize anything. And we can change the earth in ways that are irreversible.

LAKE FAUSSE POINTE – JANUARY 5, 1994

I saw only two people today–a couple of men in a commercial fishing boat, raising nets. I didn't approach them, preferring to go through two days and two nights without hearing the sound of a human voice. I purposely didn't bring a radio. The silence is unique....and powerful.

The depletion of old-growth forests is anything but unique to Louisiana and the Pacific Northwest. It goes on every day wherever ancient forests still exist. The Rainforest Action Network in San Francisco provided me with the following:

On a worldwide basis, nearly two percent of all remaining rainforests are being destroyed each year. That comes to seventy-eight million acres annually, or 214,000 acres per day. An area equal to the size of two football fields is being cut down or burned every second. The corresponding loss in species of plant and animal life that will never again appear on earth is one every ten and a half minutes.

The Atchafalaya Spillway (that part of the Basin between the East and West Levees) contains about 900,000 acres. At the rates above, a woodland that size could be laid flat in a little over four days.

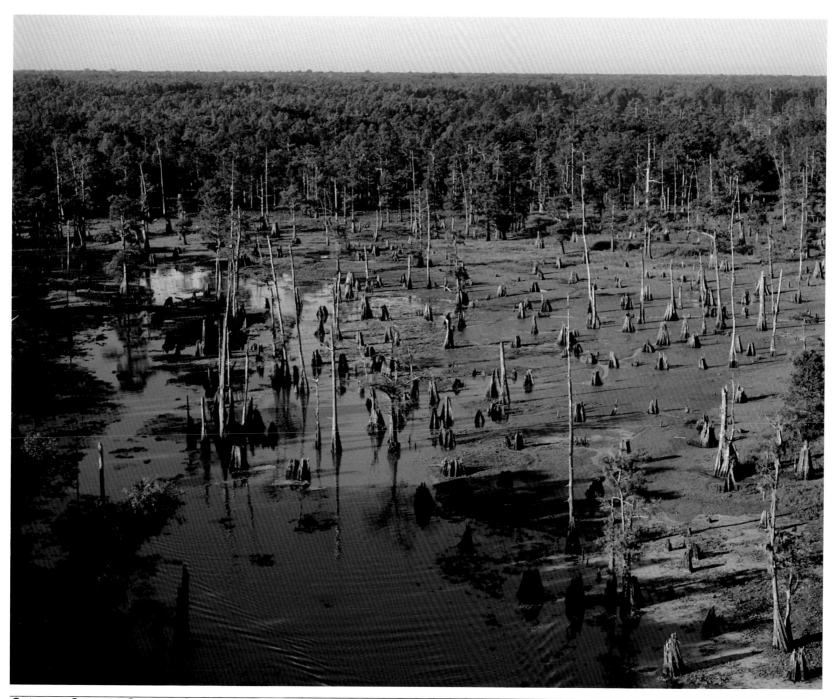

Cut-over Cypress Swamp, St. Martin Parish – September 1985

CAMP ON ATCHAFALAYA RIVER – MARCH 29,1994 –
7:30 P.M.

All four of the books I've written concern, in some essential way, the tragedy of the destruction of the great cypress forests of the Atchafalaya Basin. Every last cypress tree that was big enough to make lumber economically was cut down. No-one seemed to have the wisdom or the power to put an end to that process before it was too late.

Thoreau said, "In wildness is the preservation of the world." I can't explain, even to myself, exactly what he meant, but I can feel it. Every time I leave my house (and my telephone) and get into my boat to go out to the swamp–to photograph a red sunrise or a foggy morning, to run my crawfish traps, to smell the river or check on the white pelicans, I sense what he meant, intuitively, instinctively. I feel a kind of easy, free, peaceful spirituality. There's something close to magic here, something essential

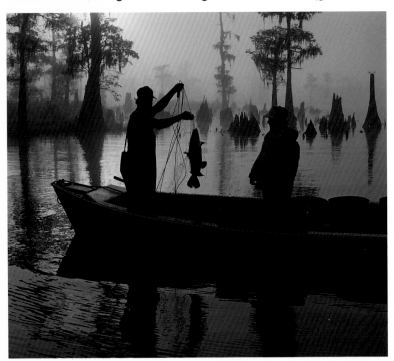

Roy and Annie Blanchard with Yellow Catfish, Bayou Benoit – October 1992

to the human spirit.

We've lost the battle to preserve any of the giant cypress trees. Unless we can live a thousand years, we'll never see anything like that again. But the battle to preserve and even to restore the swamps and other wetlands of South Louisiana is not yet lost. What's at stake here, beyond economics, is the welfare of the human spirit.

Forty or fifty years ago it was only natural for a child in America to be able to experience the outdoors first-hand. A much larger percentage of the population was rural. In spite of that, we have grown up to be destructive and exploitive in our approach to nature. I suspect that the majority of children in America today experience nature primarily, if not exclusively, over the television or on some other kind of electronic screen. What will be the attitude of these people, as they reach adulthood, toward the world of trees and rivers, birds and animals, grasslands and deserts, swamps and marshes? Is it possible that they will act even more irresponsibly than we have? The man who concluded that "in wildness is the preservation of the world" had experienced wildness. Many of us will not have shared that increasingly rare experience.

When I was a young boy living three miles from Catahoula Lake, things were significantly different. Roy Blanchard lived about a mile from my house, through the woods; and he and his friend Raymond Guidry would milk their family cows, then run their catfish lines in the lake, before going to elementary school, barefooted.

Now the trail through the woods is a highway, and young boys don't run catfish lines before going to school, much less milk the cows. It distresses me to realize that the world we live in now may be most accurately described as a sort of Cajun Theme Park. That which was genuine has become increasingly artificial.

William Faulkner was always wary of change. He felt that change, unless it was controlled by wise people, could destroy things that are not only valuable, but irreplaceable. That is what has happened here.

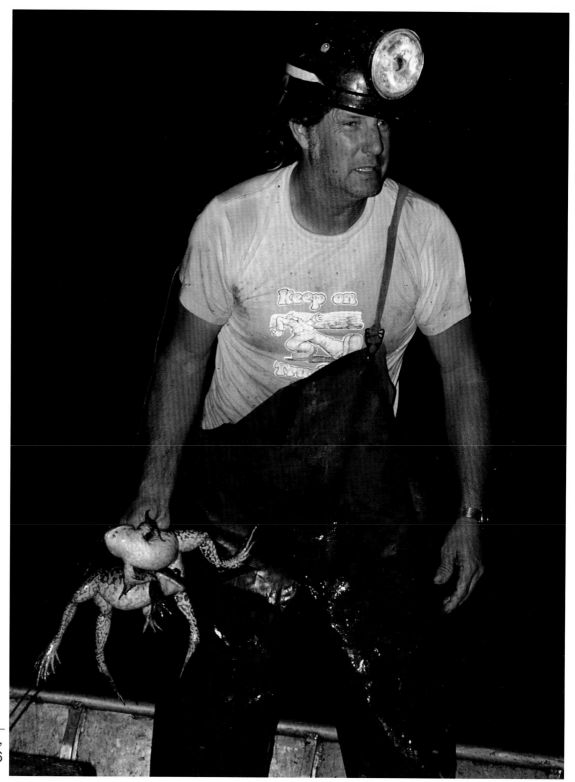

Roy Blanchard with Bullfrogs,
Red-eye Swamp – Fall 1986

GAY'S SLOUGH, RED-EYE SWAMP – DECEMBER 2, 1992

I shot a few sunrise photos from the rear deck of Roy Blanchard's houseboat. There was very little fog. Then I stopped to see Roy and his gang working on the SiBon Canal, clearing trees that were knocked down by Hurricane Andrew in August. Two men had stayed on a houseboat to make chicken and sausage gumbo, fried bread and baked sweet potatoes. They cook every Wednesday and on other days eat sandwiches. Last Wednesday they had squirrel and rabbit sauce picante at Beau Bayou, cooked over an open fire up on the bayou bank.

B and T.W. came out around 9:30 A.M. We visited Roy, went exploring down Gay's Slough, came back to the houseboat for fried catfish layered with onions, on French bread, cooked on the deck of the houseboat in the clear winter light. They left around 1 P.M. and I began exploring, marking stumps on the bayou with stakes so that people won't hit them after high water covers everything.

I shot the sunset in the SiBon Swamp near Roy's houseboat this late autumn afternoon. The sky was a deep winter blue, temperature about 40°F. I sat on the rear deck, and a mink came within twelve feet before seeing me. Then he paused and backtracked into the swamp.

ATCHAFALAYA RIVER – SUMMER 1988

If I heard it once on the weather news, I heard it ten times – no rain on Wednesday. Today is Wednesday. It's been raining for two hours. I'll be lucky to get a sunset out of this day.

RED-EYE SWAMP – DECEMBER 3, 1992
Clear blue sky, temperature high 30's

I made sunrise and pre-sunrise shots on the south side of the SiBon Canal this morning and saw ducks, mink, nutria. I returned for a breakfast of fried catfish and onions, cous-cous*, bacon and eggs, French bread, coffee. Something about this place seems to agree with me. Listened to "Morning Edition" on NPR while cooking and eating–a good experience, like sharing myself with an old friend.

* cous-cous is an easily-prepared cracked wheat dish that can be substituted for rice; not to be confused with *couche-couche* made from cornmeal.

Duane and Carol Patin on the Atchafalaya River
Summer 1988

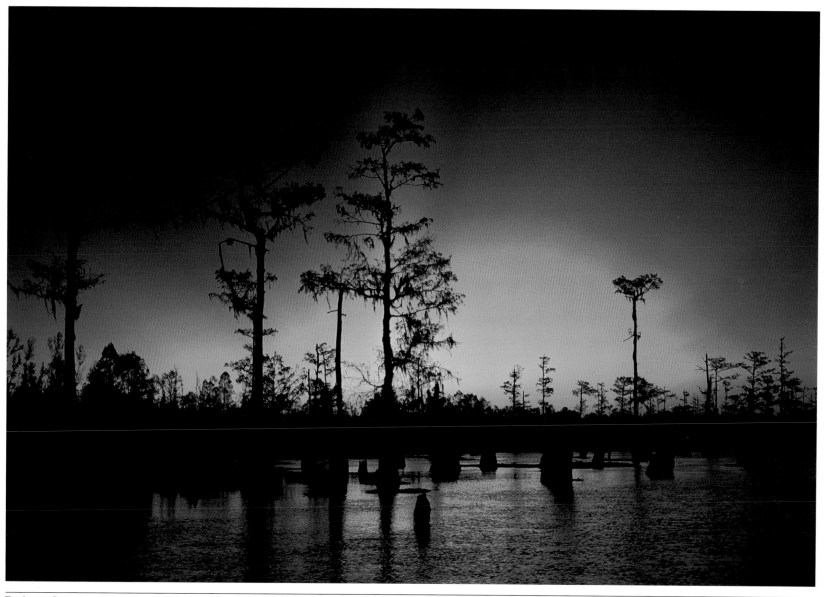

Before Sunrise near Gay's Slough – December 1992

...was the world created as some kind of backdrop for human activity or for some essential reality that we don't even understand? Or for any particular purpose at all?

BAYOU CHENE – DECEMBER 23, 1992 – EVENING
River: 11.25 feet

Tomorrow is Christmas Eve. The air is very warm for this time of year, and very still this evening.

I lit the propane refrigerator, took too much time, and got to the river a minute or two late for a good sunset shot. A low fog began building on the bayou just before sunset. Very quiet–no boats, no planes, no wind. The fog was pretty thin and very low–a five or six-foot layer on the surface.

From a distance I could see a thick blanket of fog six or seven feet high all across and up and down the river. It was a strange, quiet feeling, magical. Rushed to the far bank and got a couple of shots of the sun that broke out just before setting. I may have been too hurried to hold the telephoto steady. Beautiful. Wish the sky had cleared a little more and a little earlier. I set the tripod up on my boat deck for shots with the 6 X 7 Pentax.

Shot several images after sunset. A boat passed, invisible in the blanket of fog. I came back to camp feeling that I was riding my boat across the top surface of a thick cloud. I had to drive standing to be able to see at all, guided by the tops of trees on each bank. Glad not to encounter another invisible boat, or a log. It was an odd, unreal feeling to be speeding through a fog blanket. Hope it's like this in the morning, but there's a cold front coming, with wind. It's warm this afternoon: 65-70°F. But 45°F. is expected tonight, and 35°F. on Christmas night, or colder.

Later: The cold front came in about 11 P.M.: gusty wind and rain, hard and light, alternating. I began reading again–Faulkner. Tomorrow is Christmas Eve, 1992. Henry David, I wonder how you would feel about this place. And you, Peter Coyote.

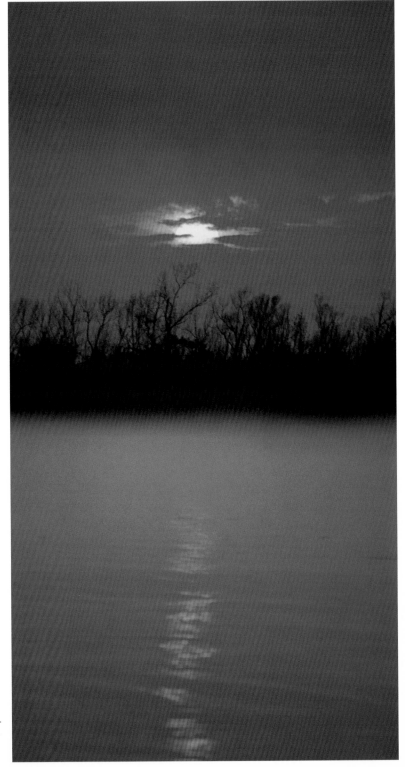

Foggy Sunset on the Atchafalaya River –
December 1992

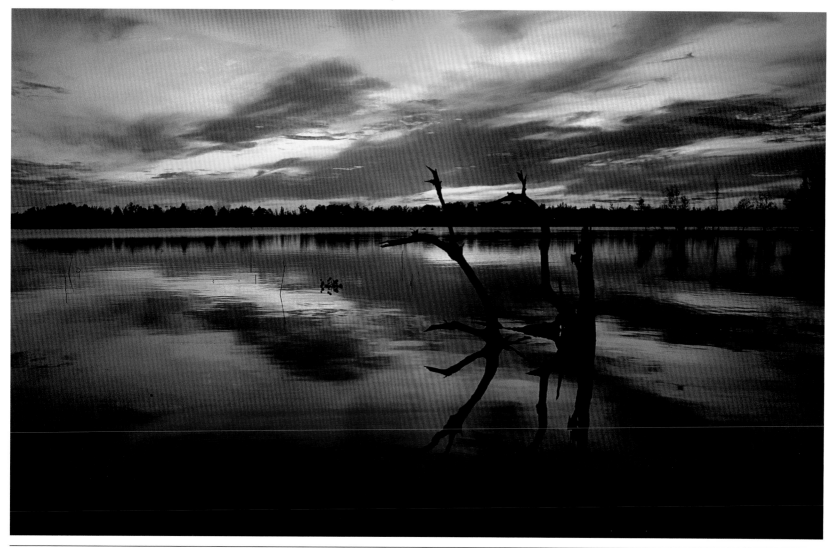

Sunset at Crook Chene Cove – June 1994

ATCHAFALAYA RIVER – JUNE 1, 1994

Handled phone calls, read a book, fell asleep. Couldn't decide whether to come to Myrtle's on the river tonight or not. Too much to do, too much everything. I was agitated, undecided, unsettled. Finally decided to do it, left home at 6:55 P.M., left the Benoit landing at 7:25, got to Crook Chene Cove about 7:50. Sunset in progress.

Got some good shots, I think, with three cameras.

Came on through the rock dam, down the Phillips into the river and on to Myrtle's about 8:45; sky was still beautiful, with the residue of an Atchafalaya sunset.

Very quiet tonight, except for rain frogs. River is down around 13 feet. It was 19 feet last time I was here. I've been gone too long.

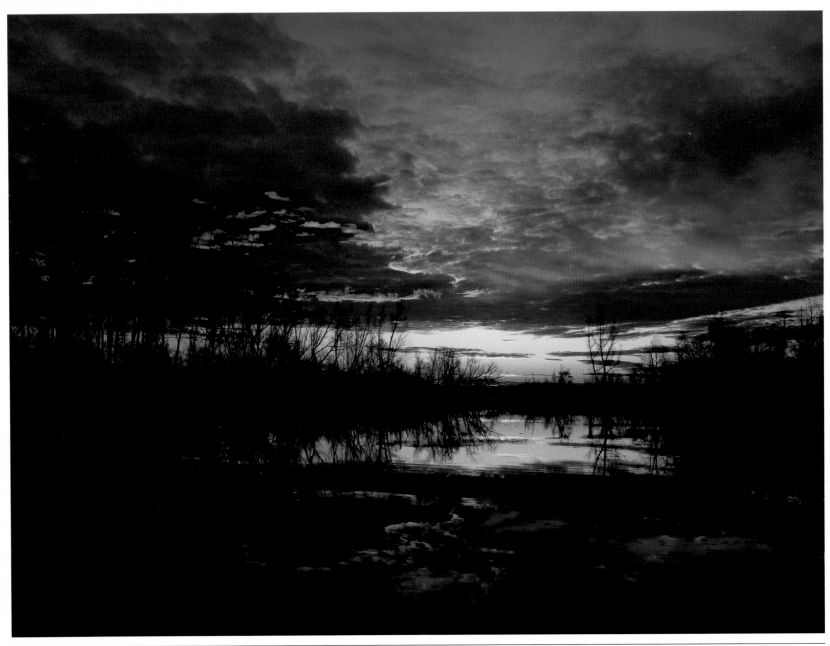

Sunrise at Henderson Lake – October 1993

There is no place on earth where I feel more at home than in the great Atchafalaya Basin of South Central Louisiana.

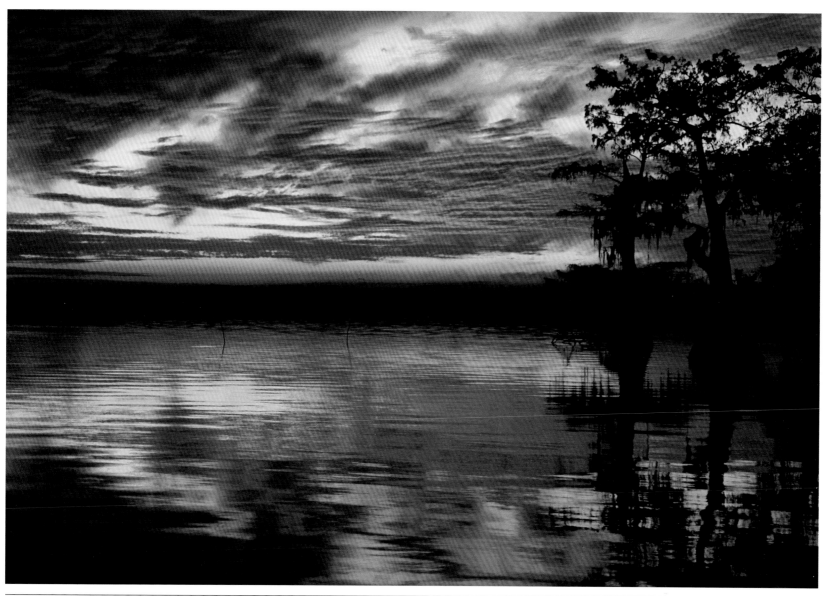

Sunset at Lake Dautrive – November 1992

This book is largely a result of my attempt to return to the woods of my childhood, the Atchafalaya Basin of my youth. I was bound to fail, of course, since that young boy and that place and time are gone now...

TOOTSIE'S CAMP – ATCHAFALAYA RIVER –
JANUARY 15, 1994

I got to Myrtle's place on the river about 5:15 P.M., took a couple of sunset shots, but the sun itself wasn't visible. The river is very low for this time of year. I met Errol Verret at T-Sue's camp about ten minutes after I had seen and photographed a beautiful Virginia white-tailed buck swimming across the river and climbing the bank, cold and exhausted. A hunter with binoculars and high-powered rifle arrived just too late to shoot him, and I got in the way anyhow. He saw the deer and was very much disappointed at having missed getting a good shot. Ha! There are only two more days left in this hunting season.

There are hunters at every camp, and the smell of woodsmoke is fine in the late afternoon. I was only ten or twelve feet from the deer when he climbed out of the water—my favorite image of this beautiful day. I ate a lemon moonpie to celebrate.

LAKE DAUTRIVE – NEW YEAR'S EVE –
DECEMBER 31, 1992

I went out around 3 P.M. to set up photography of The Basin Brothers band in a huge cypress tree I had scouted earlier, in November.

The band came out around 3:30 or 4:00 in Errol Verret's boat and they sat in various positions in the tree, with and without my pirogue as set dressing. There was a tightline hooked to the tree, and a man and boy baited it while I was checking angles, branches, light. The man turned out to be an old 1st grade classmate of mine from Catahoula, whom I hadn't seen in over forty years.

I got good shots of the band, I think, lots of them anyhow. The sun was a yellow, then reddish-orange ball; the lake was flat and without a ripple. It was a good way and a good place to spend the last afternoon of 1992.

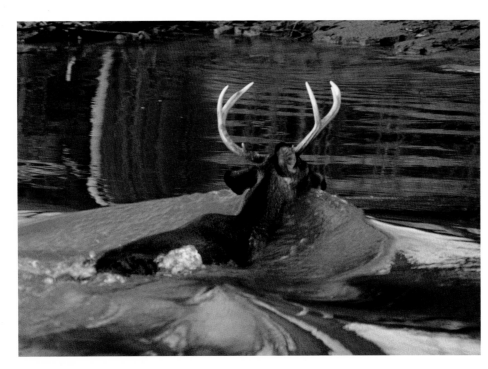

White-tailed Deer Swimming the
Atchafalaya – January 1994

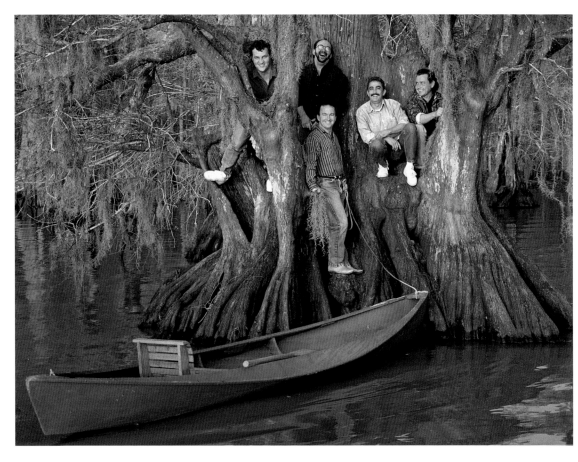

Basin Brothers at Lake Dautrive –
New Year's Eve 1992. Left to right:
Keith Blanchard, Dwayne Brasseaux,
Al Berard, Tony Latiolais, Errol Verret

LAKE FAUSSE POINTE – FEBRUARY 13, 1994

Al Berard (Basin Brothers) asked me a few days ago if I believe in God, how I feel about Christ and religion in general. I said there are certain mysteries beyond my capacity to understand and therefore beyond my ability to believe or disbelieve. "You've got to see it for yourself, eh, with your own eyes?" No, I said, it would take more than that, I'm afraid. Lots of things I see with my own eyes are still big mysteries to me. Almost everything is. That's what *The Land of Dead Giants* is all about, underneath it all. How can people know as much as they claim to know, I wonder. That's another mystery. "They'd map roads through Hell with their crackpot theories."–Grendel. I know almost nothing, if not nothing.

But it's getting too dark to go on writing without lights; this I do know, so I'll quit for a while and watch the day slowly darken into cloudy night.

BAYOU CHENE – JANUARY 3, 1993

Errol Verret killed an eight-point buck today on the river. His camp at Lake Mongoulois is two or three miles up-river from the one I'm using at Bayou Chene. Errol's grandfather lived most of his life in the Atchafalaya Basin. He and my grandfather were good friends all their lives, and they shared a deep reverence for the big woods. Today Errol is my closest neighbor, a mile up the bayou, and we share the same feelings toward that special place on earth.

LAKE FAUSSE POINTE – NORTH SHORE
Nighttime – January 4, 1994

My plan is to come here every week for three days and nights and do photography and writing for my new book. I've been working on the photography and the writing for years, but this is my first day and night at Lake Fausse Pointe, and I wanted very badly to catch the sunset. Time was running out, so I took off from my house at 4:10 P.M. in my '79 Cadillac. I had a blowout about five miles down the levee, changed the tire in exactly five minutes. Next I noticed steam coming from under the hood–broken water hose. Fixed it temporarily and headed on to Roy Blanchard's where I had left one of my boats in the water behind his house. The boat had been pushed up on some rocks and cypress knees by a strong north wind. Then the water dropped, leaving the boat stranded. With super-human determination I muscled it back into the water and loaded everything into it–gasoline and oil, bedding, food, battery for lights, cameras, propane stove, more food, flannel sheets, you-name-it. Finally I got out on the water, with the sun close to setting. The sunset at Lake Fausse Pointe, shot from behind big cypress trees, was fine. A golden glow stayed in the sky for half an hour after sunset. When all the light was gone, I went to my houseboat and ate: crawfish etouffée cornbread, salad of cabbage, carrots, apples, raisins, pineapples. Then I sat here to write: My propane stove is blazing away.

It's very quiet and peaceful here, no boats, no dogs barking, no frogs croaking, no automobile sounds, nothing but tiny waves lapping on the side of the boat, the sound of my stove, and some gurgling among the cypress knees and tree trunks. I'm getting there, Henry David.

I feel very good about this venture, this time I will spend trying to make a book that is very personal, and trying to slow down so that I can enjoy being myself and doing what I do. Today was a beautiful beginning, though it seemed I was destined to get out here too late. The evening light was magic. The trees seemed to glow. Far out across the lake, more than two miles from the house-boat, I could see a large flock of white pelicans, and they glowed too, with a kind of golden-pink color. I have a strong feeling that there is no one within miles of where I sit. And that is fine with me.

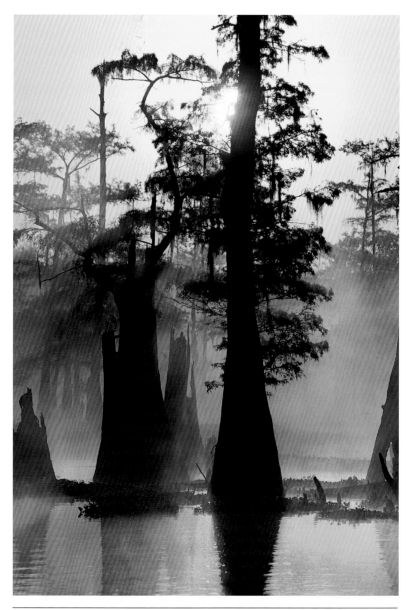

Foggy Sunrise at Bayou Benoit – October 1987

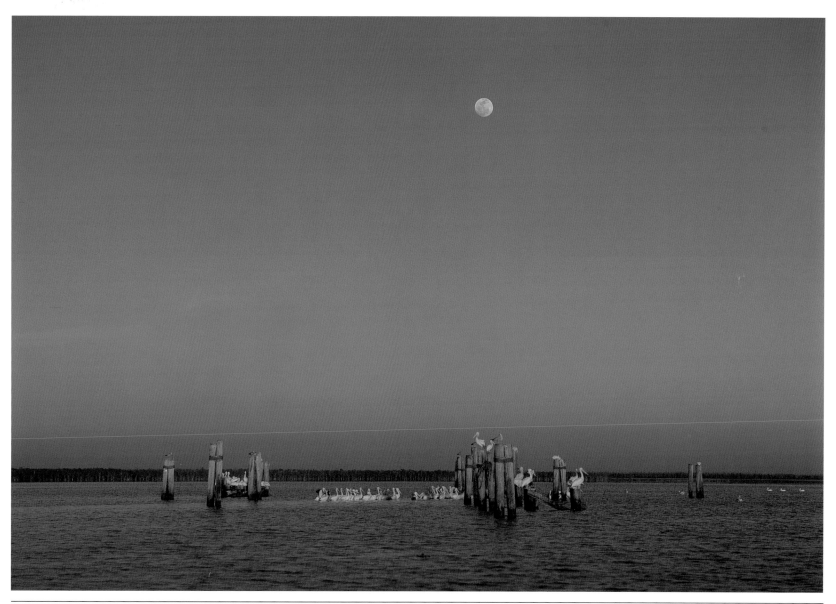

White Pelicans at Sunset with near–Full Moon on Lake Fausse Pointe – January 1994

The evening light was magic. Far out across the lake...I could see a large flock
of white pelicans, and they glowed...with a kind of golden-pink color.

LAKE FAUSSE POINTE – NOVEMBER 10, 1994 –
Thursday

I got here about 12:30 P.M. and baited my catfish
lines with chicken gizzards and hearts. Then I began con-
structing a small platform among a group of three cypress
trees right in line with a photo I've been wanting to make
and haven't gotten right yet. The image is to be a sunrise
shot through a corridor of big trees, cypress knees and
moss. A floating boat is too unsteady, and when I'm in the
water with my tripods, the camera's too low, and I'm unable
to get any space of water between the knees and the big
trees in the distance. The platform will help correct the
problems of movement, and the perspective.

I worked from 1-5 P.M. and came up short one board
and one 2" X 6" beam, but I'd finished. I rested and had a
cup of coffee on that solid little platform–all cypress–satis-
fied with myself.

Time for supper–cous-cous, chicken and sausage
gumbo. The north wind is blowing, whistling through the
cypress trees. I look forward to lying on my bed, listening to
the wind and drifting off to sleep. There isn't much chance
for fog in the morning with all this wind, but if the sky clears,
I'll be happy.

I think I had more fun building the little platform than
I've had doing anything else for a long time. I'll spend the
night there sometime: a cypress platform, supported by
cypress trees, to help me get a photograph of a cypress
swamp at sunrise.

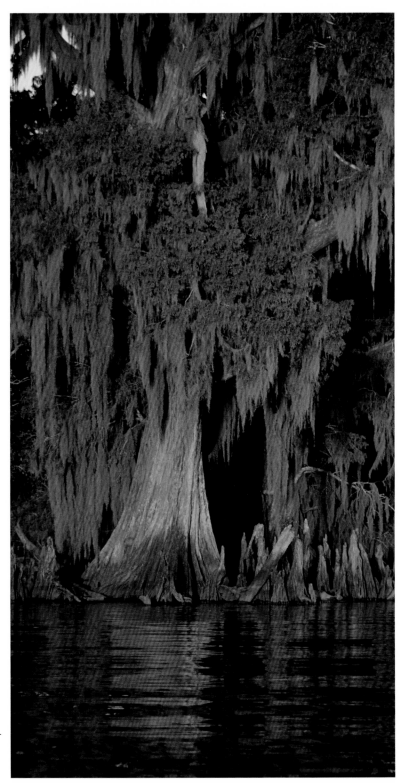

Magic Hour at Lake Fausse Pointe, November 1985

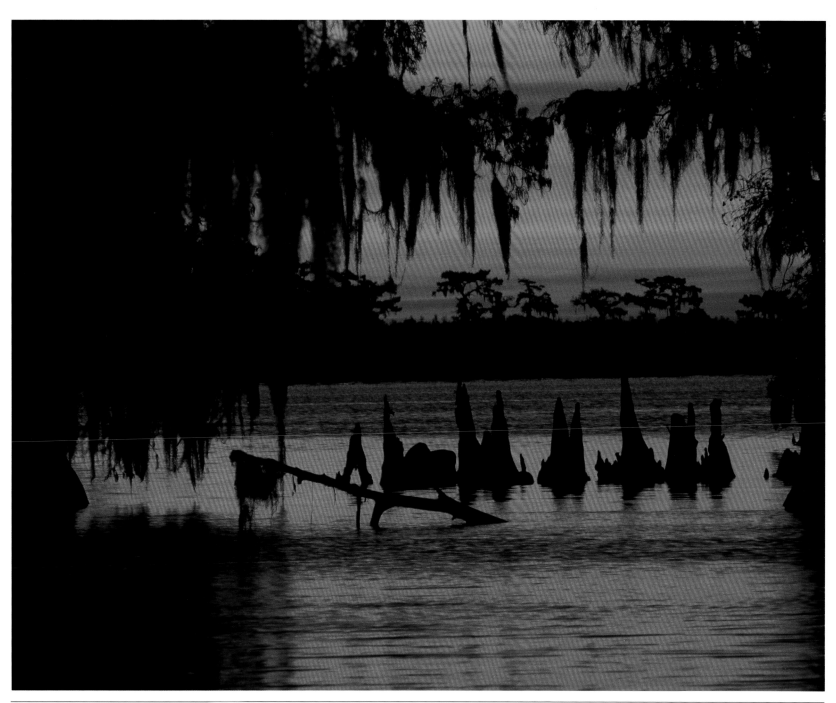

Before Sunrise from the Platform at Lake Fausse Pointe – November 1994

LAKE FAUSSE POINTE – NOVEMBER 15 & 16, 1994
Around midnight

I left home about 11 P.M., and headed for the house-boat. The moon is very bright, so I decided to travel at night in case there is fog or any other problem that might develop in the early morning before sunrise at 6:31. I feel compelled to get the sunrise shot I've been missing, for one reason or another, for a week. My window of opportunity is gradually closing. I missed a clear sunrise this morning, because I wasn't here. As much as I've wanted fog before, I don't want it at first light. I need to see the sun as soon as it clears the horizon.

My cameras are less ready than I. I can't trust the exposure; the light meters are "off" in two cameras with tele-photo lenses. And I'm supposed to be a professional pho-tographer? It's shameful. I won't know until I see the devel-oped film whether I've adjusted properly to these cameras' inaccuracies. I can't afford a really good camera and lens at this time.

There were hundreds of egrets roosting in several big cypress trees at Greg's Point. A barred owl sat on a cypress knee near the water, but it flew off before I could get a flash photo. It's a little past midnight, and I'm writing by candle and flashlight; forgot to bring my car battery for the twelve-volt lights in the houseboat.

The water is calm and the moon is beautiful. So far I've seen two falling stars. I could see pretty well to get out here, but not as well as in daylight. The trip was a little dan-gerous, and I couldn't go full speed for fear of hitting oil exploration equipment, fish lines, stumps, crab traps, logs. My catfish lines baited with chicken parts caught nothing. I'm going back to Spam® Lite in the morning.

It's been really warm and beautiful today. The tem-perature at 12:45 A.M. is about 65°F.–another magnificent night in the Atchafalaya Basin.

7:25 A.M.:–Missed it again! At 5 A.M. the moon had set, the sky was perfectly clear, there were thousands of bright stars, and winds were calm. By 5:30 there was not one star visible; there was a slight breeze, no fog, and a thickly clouded sky. I went to the platform anyway and set up three cameras on the slim chance that the sun might break out for a few seconds on the horizon. It didn't hap-pen. There was a barred owl sitting on one of the cypress knees in my shot, the same one I had seen at midnight probably. There wasn't enough light to get a good shot with the 500 mm lens, and there was no sunrise.

I'm going home now, where visiting friends are wait-ing. I'll be back here tonight or early tomorrow unless it's actually raining. Something seems to be conspiring to make me miss this shot.

LAKE FAUSSE POINTE – NOVEMBER 20, 1994 – 6 P.M.
Temperature 72°F.

I came to the lake at 4:50 P.M. to find a nice sunset. Brought more wood to extend the platform further left so that I can use a tripod if the sun has moved too far south for me to get it from the main platform. I think I've been out here nine out of ten mornings, and I've never gotten the sunrise I need. The sun's not going to wait around at east-south-east forever. I don't want to get it in late January when the sun's moving north again, because all the beauti-ful red leaves on the distant cypress trees will be gone. Besides, I need to wrap up the photography for this book by the end of December if I can. Ha!

It's supposed to rain tonight and clear up before sun-rise. Double Ha! I'd like to see that. I'm having quite a struggle with myself to come out here day after day, at mid-night or 4 A.M., only to fail every time. I'm running myself ragged and not getting enough sleep.

I'm reading *The Bear* (Faulkner), as I do every November. It's one of my most pleasurable rituals. What a genius! Faulkner said, "If all the destruction of the wilder-ness does is give more people more cars just to ride around in, then the wilderness was better." I suspect he really believed that the wilderness was better than any product of its destruction, but he held back a little.

7:25 P.M. – November 20, 1994

I'm getting sleepy. I had to finish platform construction in near darkness, long after sunset.

LAKE FAUSSE POINTE – NOVEMBER 21 – 6 A.M.

It's cloudy but clearing. I'll go to the platform again and set up and hope for a sunrise.

7:15 A.M. ALL RIGHT! Maybe I got it..........

The sunrise this morning was an easy 10! It was golden, and it came right through a narrow slit on the horizon. It was a gift, but it lasted only a few seconds before clouds moved in to cover it.

I say *maybe* I got it because I don't know whether my two cameras with big lenses (500 fixed, 75-260 zoom) are exposing accurately.

To top it all, a great blue heron sat on a tiny branch right in the shaft of light coming directly at my little platform from the huge, golden sun. And the white pelicans far in the distance were not hidden by haze, fog or mist. I feel a great sense of relief. At least there was a sunrise. If I didn't get it, I can only blame myself.

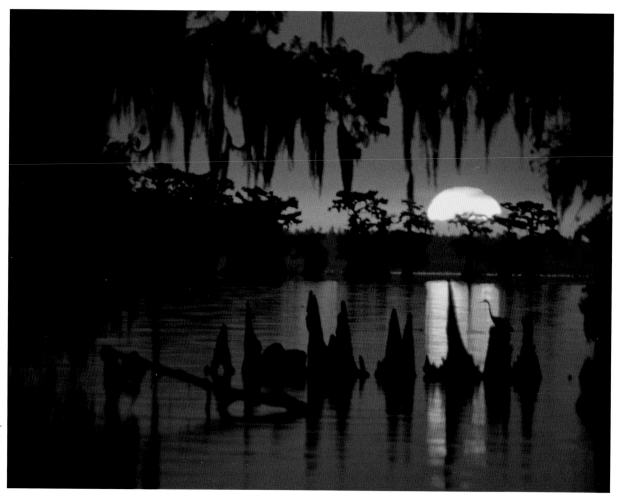

Platform Sunrise # 1 on
Lake Fausse Pointe –
November 1994

LAKE FAUSSE POINTE – HOUSEBOAT – NOVEMBER 21, 1994 – 6 P.M. – Temperature 69 °F.

This afternoon I went to the platform to check out a camera I borrowed at 3 P.M. from my old friend Peter Piazza, in Lafayette, and arrived just after a clear, bright sunset. The camera is a motor-driven Nikon with a 300 mm 2.8 lens–beautiful! I don't know how other photographers can afford equipment like this, but I'm plenty happy to be able to borrow it. Peter was leaving town, so I have several days to take advantage of his kindness.

I picked up a small pack of photos I had taken a few days ago to test the Canon body and 75-260 lens I've been using. The color prints looked good, just a little under-exposed, the way I like them. I'm more encouraged now that I got something good at sunrise. I used that camera more than the others in my arsenal, this fine morning.

Going to the mid-40's tonight, with a clear sky fore-cast for tomorrow morning. Today around noon I stopped at Roy and Annie Blanchard's at Bayou Benoit. They were having fried venison, venison stew, white beans and rice. Roy said, as usual, "You're just in time; grab you a plate, man." So I did, of course. They're always having some-thing great for the noon meal (I know when to arrive): squirrel, sausage and chicken gumbo, venison, rabbit or tur-tle sauce picante, river crabs, and every other delicacy known to Cajuns. They're very good to me.

The light this afternoon was beautiful–that magical Lake Fausse Pointe red that I've seen so often on clear, cool days. I shot several images down the same cypress corridor that I used for this morning's sunrise, with the white pelicans still visible across the lake to the east.

There are hundreds of thousands of mosquitos on the screen windows and doors of my houseboat. They aren't going to like it much when the temperature drops into the 40's. There is no wind, so the water is beautifully calm and reflective. The moon will be rising soon; full moon was three days ago. The moonrise last night was fine, but I chose not to photograph it. I just looked and enjoyed–get-ting extravagant. The mosquitos would have eaten me up anyway.

Sometimes I realize that I'm missing the essence of a beautiful sunset or moonrise, because I'm concentrating too much on getting the best exposure or the best composi-tion, and I'm not focused on looking at the image that I'm trying to record on film. I'm missing the experience itself, even though I know I'll see it later in my photographs. I look forward to the time when I can observe and enjoy the beau-ty of the world around me without feeling the need to cap-ture it on film.

Roy Blanchard with Dog and River Crabs – Fall 1984

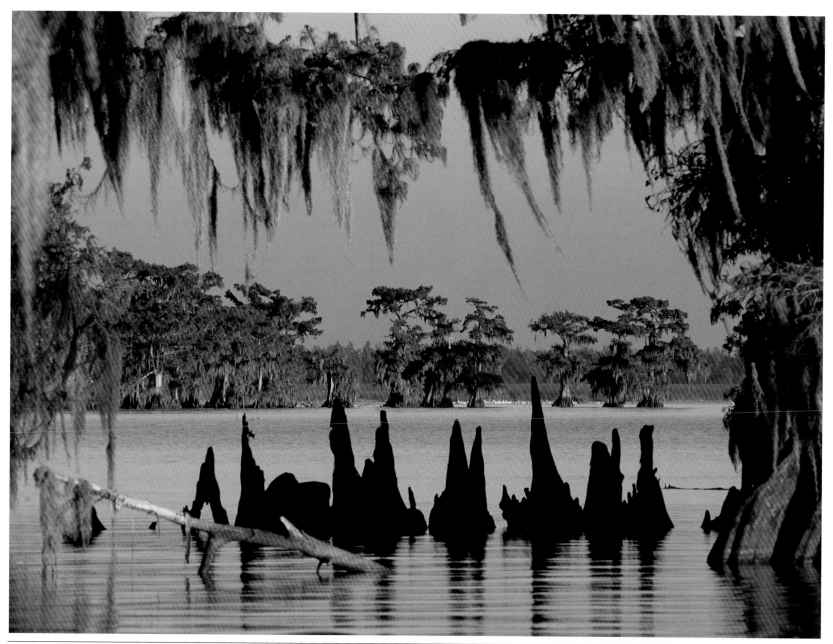

Late Afternoon from Platform on Lake Fausse Pointe – November 1994

LAKE FAUSSE POINTE – HOUSEBOAT – NOVEMBER 21, 1994 – Temperature at 8:30 P.M: 62°F.

The moon has just come up. I got a couple shots of it reflected in the water, from the front deck of the houseboat, with no apparent movement. That's how perfectly calm the water is. A flock of geese went over, their honking clear and deep in the otherwise total quiet.

Yesterday morning at sunrise, while I worked frantically for the few seconds that I could see the sun, I could hear geese flying high, ducks whistling by over the trees that support my platform, ibis going by in various directions, a multitude of cormorants and anhingas feeding to the northwest–so many of them that it was a constant rumble that I couldn't identify at first–thought it was some kind of engine. They were too far away to see clearly. There was also the occasional hooting from barred owls and squawking from a great blue heron or American egret, but the frogs were quiet.

It's 8:45 P.M., and I'm going to bed with my copy of The Bear. Thank you, William Faulkner.

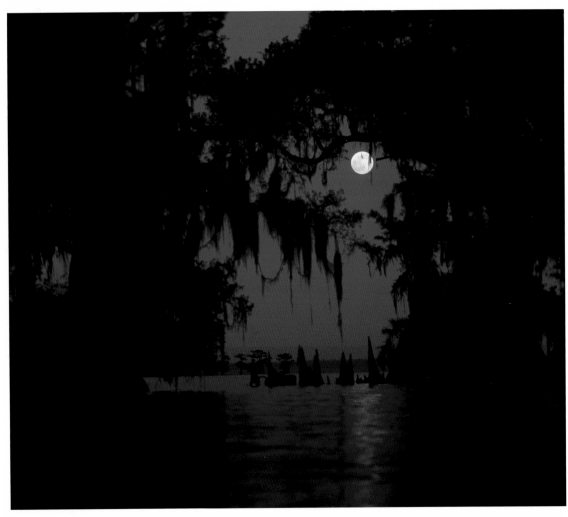

Moonrise with Johanna Silverman at
Lake Fausse Pointe – June 1995

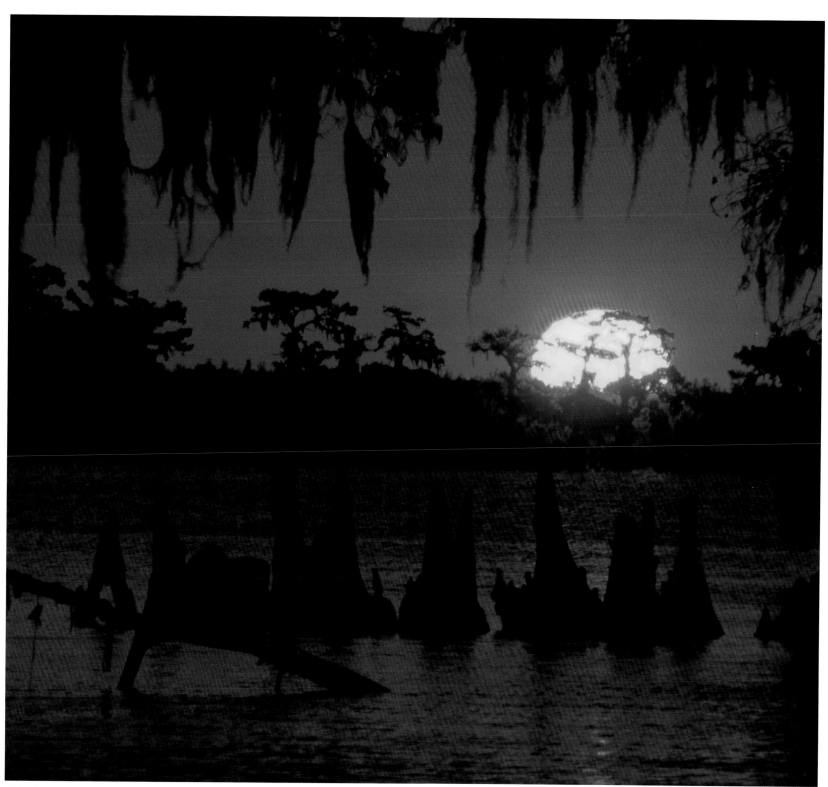

Platform Sunrise # 2 on Lake Fausse Pointe – November 1994

LAKE FAUSSE POINTE – HOUSEBOAT – NOVEMBER 22, 1994 – Temperature at 4:45 P.M: 49°F.

I was back on the platform by 4:30 P.M. yesterday after going home, getting my mail, shipping some note cards and books, making phone calls, filling my fuel tanks at Catahoula, feeding the cats and dogs, restocking on film, rustling up some grub, rushing, rushing. Don't look now, Henry David.

The color of the trees, water, air during the last half hour before sunset was spectacular. I'll have to look back through old slides and photos, but I can't remember ever seeing this intense, unreal quality of red light anywhere else. Tonight the temperature will be about 38°F. A good fog could develop if the wind stays calm.

I could see the white pelicans clearly through my bigger lenses; as the afternoon progressed, more pelicans landed among the flock on the water. I added an extender to a borrowed lens, making it 420 mm. The distant row of big cypress trees between the pelicans and me was red and beautiful. There are some fine things in this world.

It's 41°F. right now. I'm warming the houseboat with my propane cook stove. I slept pretty well last night, but I had exceptionally strange dreams.

LAKE FAUSSE POINTE – JANUARY 5, 1995

The prevailing quality of this place this afternoon was perfect calmness...the intense quiet–no birds, no movement, no wind or waves–just *quiet.* On the houseboat after dark I cooked catfish filets and cous-cous. Then I ate and had two cups of coffee, the final one while lying in my bed listening to classical music on public radio.

LAKE FAUSSE POINTE – NOVEMBER 23, 1994

There's a strong north wind at 8:20 A.M., rocking my houseboat. Two flocks of white pelicans, about twenty birds in each, are flying by the west window as I eat breakfast. What a good place this is on earth.

Tomorrow is Thanksgiving. I have no plans. Day after day lately–red afternoons, golden sunrises, white pelicans, wood ducks, great blue herons, barred owls, bright moons–I've been thinking *Thanks.* To whom? Or to what? I may never know. Are there spirits about? Is it by chance that after failing to get a single good sunrise out here for ten or twelve consecutive days, I was given, on Monday, a spectacular sunrise, though only for a few seconds before it was taken away, with a great blue heron sitting in the golden shaft of light and the white pelicans so purely visible in the distance? What caused me to construct the little extension to my platform on Sunday night that made it possible to put my tripod exactly where it needed to be to get everything just right? On the other hand, who am I to blame if my cameras were exposing inaccurately, as I fear?

Good grief! I just ate all the Spam® Lite I had planned to use as bait on my catfish lines.

LAKE FAUSSE POINTE – HOUSEBOAT
Monday – November 7, 1994

The light had a magical quality late this afternoon–red light, blue sky, red cypress leaves, fine reflections on dark, calm water. I jumped in and set up tripods....

There's some fine classical piano music on public radio now. Goes well with the total calm on the water–no ripple, no breeze. Only two owls now, and one nutria calling–no other people, boats, airplanes–nothing. It's a fine moment in the Atchafalaya. Now I will lie in the dark, listen to the music and watch the crescent moon and dark trees with Spanish moss.

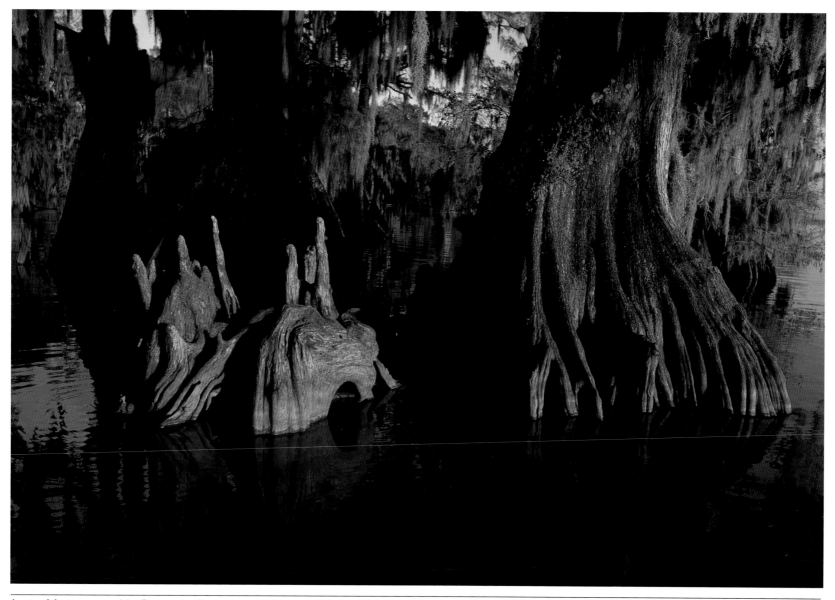

Late Afternoon with Cypress Trees and Knees at Lake Fausse Pointe – November 1994

The prevailing quality of this place this afternoon was perfect calmness...the
intense quiet–no birds, no movement, no wind or waves–just *quiet*.

BAYOU CHENE – JANUARY 5, 1993 – 9:00 A.M.
Temperature: 52°F. River: 13.4 ft.

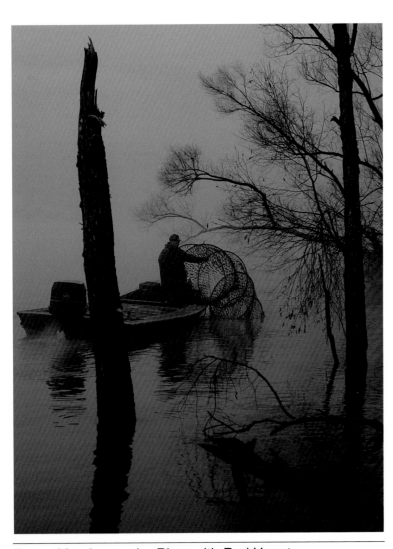

Foggy Morning on the River with Red Verret
and Hoopnet – January 1993

I hit the river with Red Verret at 6:45 A.M. I shot from his boat, and my son Jean-Paul followed and shot from my boat. Dreary gray–no sunrise. May have gotten a couple of good shots with tug and barge passing in the background. Not many fish in 25 nets–average 3-4 buffalo and catfish total per net. Often Red and other net fishermen catch over a hundred pounds of fish in each hoopnet. Jean-Paul caught a ride with Red to the Benoit landing. They'll run eight nets with leads in the woods near Grand Bayou on the way back.

Red was born here at Bayou Chene, about 1925, and his family moved away in 1930. They put their house on a raft of cypress logs and went to Bayou L'Embarras, then to Lake Rond, finally to Grand Bayou and then to New Iberia. He worked for many years as a crane operator offshore, on a 7-and-7 work schedule, and ran fish nets on his days off. His boat is my favorite–welded aluminum, with beautiful lines, a six-foot beam, twenty feet long, with forward controls. It was built in Loreauville four years ago. Fifty years back a boat like this would have been constructed of old-growth red cypress.

Like almost all of the venerable net fisherman of the Atchafalaya, Red Verret is always friendly and helpful. He has a deep voice, and a distinct Bayou Chene accent. He'll pick me up tomorrow to go up-river, toward Lake Mongoulois. Today we went down-river. It's beginning to feel like home out here on the Atchafalaya. Henry David, I'm not making any predictions.

ATCHAFALAYA RIVER NEAR BAYOU
CHENE – January 20, 1993
After midnight

I just stood on the river bank and watched a big tug boat and barges go by. It must have taken fifteen minutes at two or three miles an hour because the current is very strong, and the boat was going up-river. There were three lights on the deck of the front barge, one red, one white or light green and one red-blinking, in the middle. Now the moon is close to setting and its reflection is dim on the river. The sky is deep with stars–you can really see stars out here when there's no fog, like tonight, and no lights for miles around.

Gotta go bail the boat–3:00 A.M.–just wrote to Hiroji Kubota. He's a good man, and a fine photographer.

Rained hard–three inches between 3:30 and 6:45 A.M. Raining hard now–at 7:35 A.M. There's a 100% chance of rain through today. Flooding throughout South Louisiana. Fog is forming on the surface of Bayou Chene, in spite of heavy rain and the breeze.

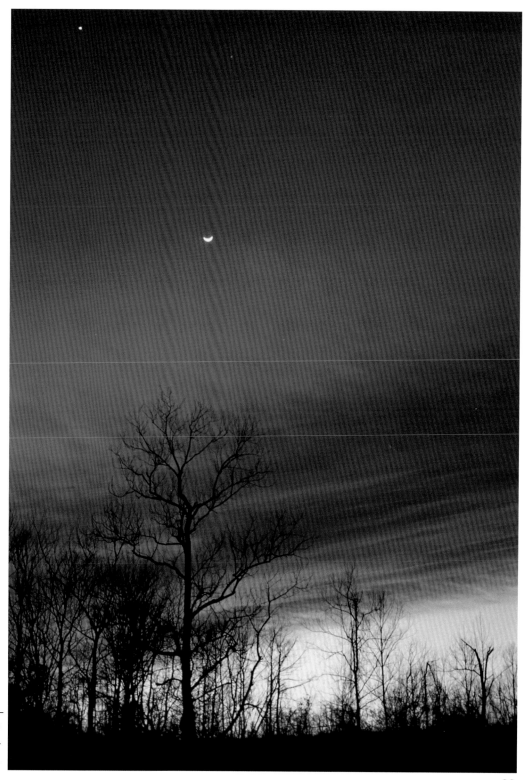

The Moon and Venus after Sunset at the Stockstill Camp on Bayou Crook Chene– January 1993

Who knows what beautiful and winged life, whose egg has been buried for ages under many concentric layers of woodenness in the dead dry life of society,....
[will]

....unexpectedly come forth....to enjoy its perfect summer life at last!

Henry David Thoreau

I went to the woods because I wished to live deliberately, to front only the essential facts of life, and see if I could not learn what it had to teach, and not, when I came to die, discover that I had not lived. I did not wish to live what was not life, living is so dear; nor did I wish to practice resignation, unless it was quite necessary. I wanted to live deep and suck out all the marrow of life, to live so sturdily and Spartan-like as to put to rout all that was not life, to cut a broad swath and shave close, to drive life into a corner, and reduce it to its lowest terms, and, if it proved to be mean, why then to get the whole and genuine meanness of it, and publish its meanness to the world; or if it were sublime, to know it by experience, and be able to give a true account of it in my next excursion.

Henry David Thoreau
1854

LAKE FAUSSE POINTE – OCTOBER 26, 1994 – A.M.

I'm looking due south across Lake Fausse Pointe at a huge billowing of white smoke, far behind the trees that line the lake. I believe it's from the St. Mary sugar mill between Charenton and Jeanerette. Last time I was here, as I crossed the lake to the west to set up cameras for the coming sunrise, I detected a strong scent of molasses everywhere. The wind came from the south that morning, and it was carrying the smell of molasses for many miles. It's a good smell, something from my childhood. My dad worked for a few years at St. John sugar mill near St. Martinville when I was a small child. He had to stay there twenty-four hours a day for three months, and we would take him clean clothes and food from time to time, though he generally ate food prepared at the mill. Molasses will always smell like those memories to me.

CAMP NEAR COCODRIE SWAMP – APRIL 23, 1993

Tomorrow I'll begin running my crawfish traps at first light, then go home and run another 100 traps in my pond before going to the Co-op, to sell my catch. Total weight of crawfish I caught yesterday–720 pounds. There were two swallow-tailed kites cavorting above the Panotec Canal yesterday, seemingly performing for my pleasure, against a deep blue sky.

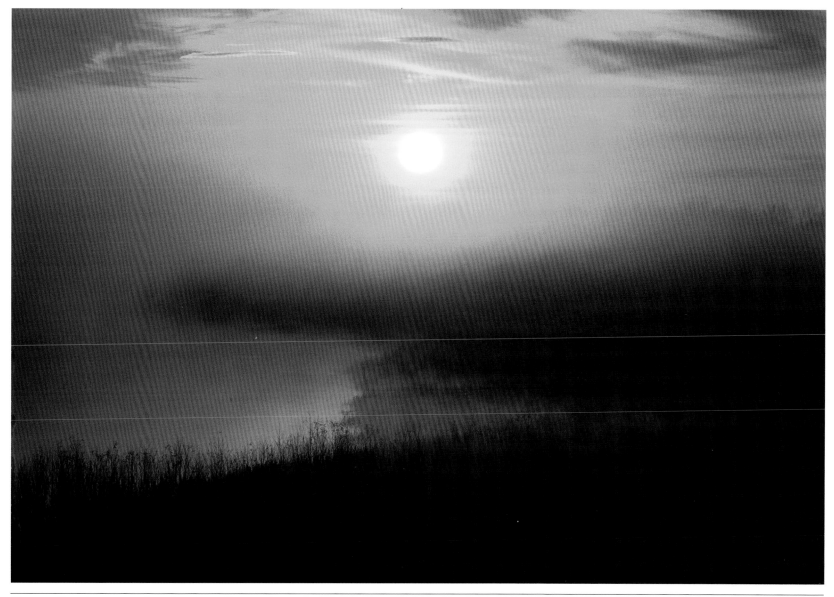

Foggy Sunrise near Catahoula – December 1993

To anticipate, not the sunrise and the dawn merely, but, if possible, Nature herself!

The morning wind forever blows, the poem of creation is uninterrupted; but few are the ears that hear it.

....I never assisted the sun materially in his rising, but, doubt not, it was of the last importance only to be present at it.

Henry David Thoreau

LAKE FAUSSE POINTE – DEC. 27, 1994 – 9 A.M.
Temp. at 5:30 A.M. 34°F. – (Transcribed from tape recording)

Let me tell you, the pre-sunrise this morning was a pure gift–spectacular. Beautiful clouds above the horizon began to catch the deep red light of the approaching sun long before sunrise itself. The sky became all the best shades of pink, red, gold, orange, yellow. Then, when I was so happy and thinking it just couldn't get any better, I began to see long lines of white pelicans coming at me out of the sunrise. There were hundreds of them and they kept on flying right over me.

The pelicans were in lines, the way they always seem to fly in the morning, rather than in regular flocks of V's. By the time those toward the end of the line begin slowly flapping their huge wings, those toward the front of the line have stopped flapping, and they're just gliding. The flapping runs like a wave through the line, each succeeding bird waiting for the one in front of it to flap before it can begin flapping. If the line is not too long, there are times when every pelican is gliding, other times when almost every one is flapping. It should be recorded on video, to catch the movement as well as the sound of those big wings beating the cold morning air.

Even without a gorgeous red sunrise sky as a background, these black and white birds with 8 to 9-foot wingspans would be impressive. After the first series of strings of pelicans came by, there was a lull. Then a second series began coming over. I was excited, awestruck, moved.

When it was over I returned to the houseboat, and for breakfast I celebrated with meat pie in sauce picante gravy, toasted roll with shrimp glacé, apple pie biscuit, and coffee.

Then I remembered last night: There was beautiful Beethoven and Mozart music on public radio every time I woke up through the night. Thanks, WRKF. Thanks, NPR. Get back into your hole, Newt. You too, Jesse.

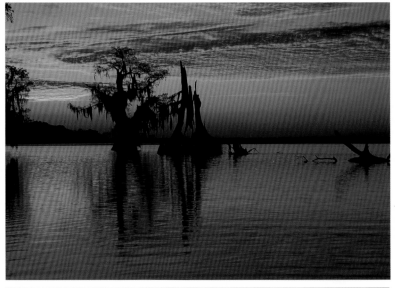

Pre-sunrise at Lake Fausse Pointe – December 1994

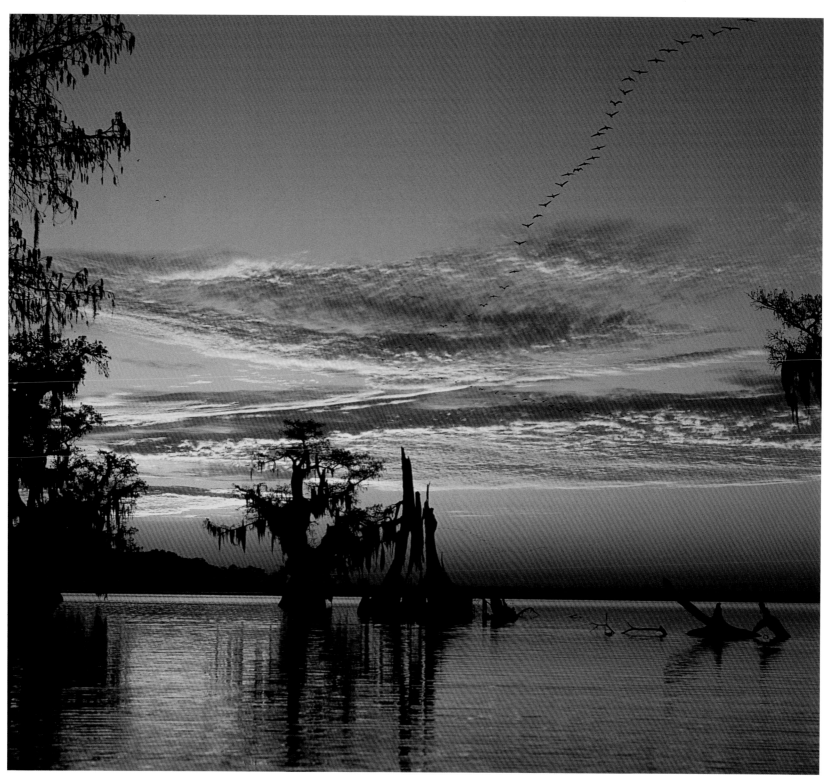

White Pelican Sunrise at Lake Fausse Pointe – December 1994

The sky has been rumbling and thundering since about six this morning, and it's darker now than it was a half hour ago. I think we'll get it again. Seems to rain about three times a day this summer.

Yesterday, Mark deBasile and I were constructing a fence for Myrtle Bigler on the river. It was hot. Wild cattle, *her* cattle, have been walking through and over her old fence and trampling her flowers, knocking her propane tanks around, and fighting in the front yard. As we were stringing wire from posts to a stump in the water, a storm began approaching from the south, from down-river. We could see it coming a mile away. The river had been calm and flat, but as the sky became dark gray and clouds blocked the sun, little whitecaps began running before the increasing wind. The breeze got down to where we were working, and it felt invigorating. The waves in the river got bigger, and Mark said, "Look at that, it's like the Gulf of Mexico." Still no rain. I took a few photos, trying to capture the feeling on film. When I turned to look up-river and photograph that aspect, I was surprised to see rain coming at us from that direction. Storm from the south, rain from the north. It seemed strange. We were reluctant to stop working and go inside, because it felt good to get suddenly wet with cold water from the sky. Besides, Myrtle was yelling at us to get out of the lightning.

Finally we retired to her front porch for coffee and biscuits. I had made the biscuits using cream of mushroom soup instead of water in the mix, and I had wrapped smothered catfish and onions in some of the biscuits before baking them. Good food, a good storm and a good cup of coffee: What more could Cajuns want from a day on the river? Mark played his accordion for Myrtle, because she loves Cajun music.

Breakfast is heating: cous-cous with cream cheese mixed in, one leftover catfish biscuit. Blue cat. I hoarded the yellow catfish pieces for some exotic later dish, like broiled yellow cat bellies on potato rolls. Mmmmmm. There are usually a few pieces of yellow cat in with the filets I buy from a friend at Catahoula. As good as a blue cat is, yellow cat is somehow better. I can't explain how. Maybe it's just an idea–something from the depths of being Cajun. And I don't mean from living in the Cajun Theme Park that we sometimes seem to inhabit today. I mean from way back–maybe all the way back to Normandy or Brittany.

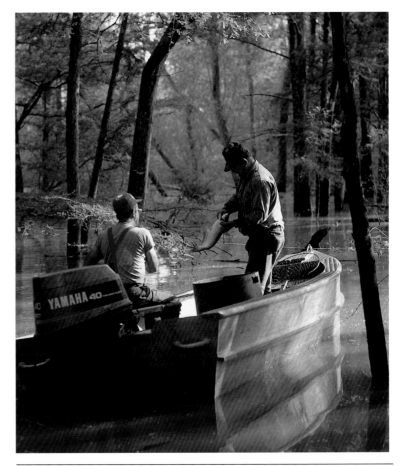

Catfishing for the Table, in the Cocodrie Swamp – Willis Lasseigne and Collins Faucheaux – Spring 1993.

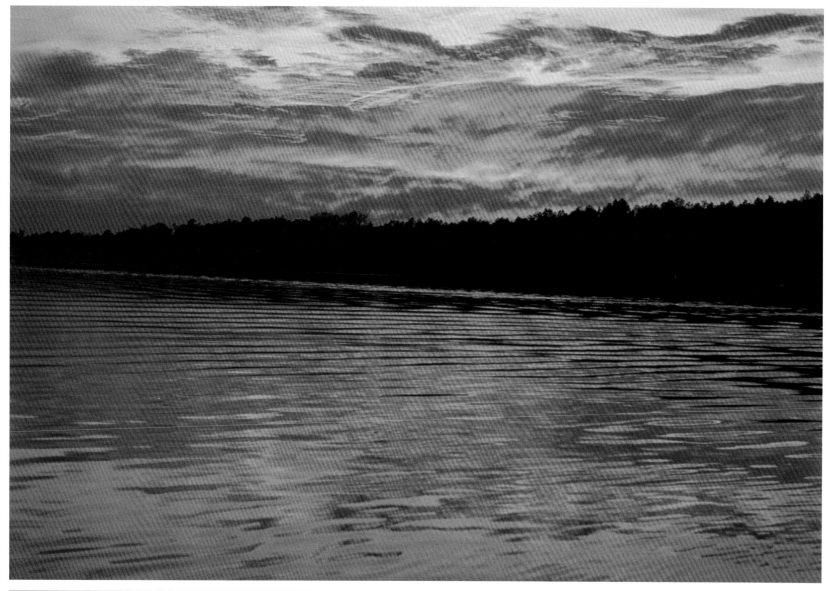

After Sunset at Myrtle's on the Atchafalaya River – Fall 1990

Good food, a good storm and a good cup of coffee: What more could Cajuns want from a day on the river?

More frequently in recent years I find myself mourning the untimely passing of the great trees of the vast Atchafalaya Basin, as though they had been people, like my grandfather, worthy of mourning, as though they possessed, each of them, a consciousness, an awareness. I didn't ask to feel this way, but a few minutes ago there were tears running down my face, the same kind of tears that filled my eyes late one afternoon on the Olympic Peninsula in Washington. I had just chosen a place to park my borrowed vehicle for the night, surrounded by enormous trees. The last light of the setting sun was filtering through the leaves and trunks, golden and textured and magical. I was alone with the trees and the light. I just stood there and cried, for a while. Then I ate my evening meal of home-canned salmon on crackers that Mike Scott, a Seattle friend, had given me. Dessert was fresh apricots, from a store a hundred miles back down the road.

I want to go out West again and see the redwoods and sequoias of Northern California, whatever big trees and coastal rocks are in Oregon, the Columbia River at Astoria, where I have a friend, and the Pacific in Washington, especially on the Olympic Peninsula.

I was hearing beautiful piano music on my radio when tears began to flow for the big trees, when I began to feel my reverence for the earth coming through. I was thinking–I can't paint, I can't write music–that I needed to express my feelings in art somehow. It's the earth itself for which I have feelings, the marshes and swamps, the big trees of the Pacific Northwest and the Atchafalaya, the rivers, the mountains, the birds and animals, everything. All I can do is record it–some of it–with cameras, what's left of it anyway.

I'm still haunted by images of the earth reclaiming itself somehow from humankind. I see deer and buffalo roaming the levee of the Mississippi in New Orleans, black panthers stalking rabbits along the Atchafalaya River, otters sliding into lakes in the centers of cities all over, trees cracking their way through parking lots and shopping malls everywhere, ducks and geese migrating without interference from hunters, airplanes, wars; wolves running through the woods, squirrels scampering out of their way, chattering at them from branches as they pass by, branches of trees that will not be cut down. I sense that the earth is waiting patiently, almost consciously, for that day, and I'm uncertain how to deal with that feeling.

The Earth Reclaiming Itself – December 1989

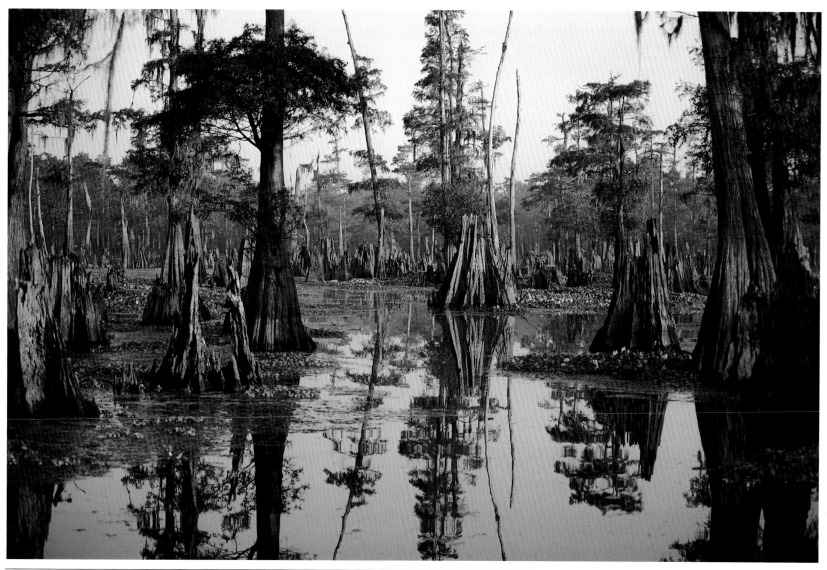

October Morning in the Red-eye Swamp – 1984

A million-acre cathedral had been converted into a million-acre graveyard–
the land of dead giants–and hardly anyone noticed.

It was drizzling and warm around 5:30 this morning when I finished Faulkner's *Big Woods*. Reading "The Old People" brought familiar tears–a boy of twelve standing among men, hunters, with the blood of his first deer on his face, the ritual of reverence for the hunt and the slain animal complete, all of it in the presence–and maybe the consciousness, though not like our own–of trees hundreds of years older than any human there: trees that would soon be chopped and sawed down, translated into boards and beams, planks and shingles and 2 x 4's to be sold for money, and into sawdust to be discarded.

I can remember being that boy, remember the warm blood on my face, spread there by Junice Savoy before I realized what he was doing. In my excitement at the kill, I had forgotten the ritual. Dewey Patin was there, too, having beaten even the dogs to where I was standing, shaking. And before long my grandfather, Wade O. Martin, Sr., whom I loved and revered more than anyone, stood there, the man who had taken me into the big woods the first time and every time until I was old enough to go without him, for rabbits and squirrels and ducks, but never for deer unless he was leader of the hunt. He died when I was nineteen, and it took me several years to understand why deerhunting without him seemed empty and unfulfilling. He was many things: the youngest sheriff in the U.S. at age twenty-one, an elected public official all his life, a farmer, sawmill owner, cattleman. But when he was a deerhunter, from late November through December each year, surrounded by the men who worked in the sawmill, rounded up the cattle, and built the barns and fences, he was truly himself.

When my grandfather was a boy, the demise of the big woods had only recently begun in the Atchafalaya Basin. When he died in 1956, the process was virtually complete: All the big trees, save those that were already so ancient as to be hollow, had been removed. The great cypress forests had been transformed into cutover swampland.

Why didn't he try to stop it? He was wise and good. Did he become wise too late in life? What is it that leads us all to allow the destruction of things rare and beautiful rather than stand up and defend them? He was an influential and respected man. Did he lack the vision to foresee what it would mean to lose the big trees? If he had petitioned the State of Louisiana to facilitate the protection of a certain part of the Atchafalaya Basin, he might have succeeded in allowing us all to inherit a thing of such beauty and majesty as is almost unimaginable here today–a piece of the past thriving into the future, an inheritance of incalculable, indescribable value to our souls and spirits. But he didn't do it.

Do I myself lack the awareness that would compel me to do something beneficial with respect to the earth that I'm not doing now, something that might be of vital importance to those who will live here many years from today? Maybe by the time my grandfather was a man of sufficient influence to attempt any such thing, it was already too late. By the end of the 1920's, the destruction was all but complete. Nobody cared enough or had the wisdom, or the vision, or the power to stop it. A million-acre cathedral had been converted into a million-acre graveyard–the land of dead giants–and hardly anyone noticed.

From the early 1940's until about the mid 1950's my grandfather and my father owned and operated a large sawmill on land my grandfather had bought here in the 1930's. The mill site was only a hundred yards from the house in which I live. It was by selling the lumber from this mill that he paid for the 1,300 acres of woodland he had purchased. Not one photograph of the mill survives today, but I recently discovered a pad of invoices for lumber products. The photograph on page 43 is superimposed over one of these old invoices.

M_____

IN ACCOUNT WITH

MARTIN AND GUIRARD

WADE O. MARTIN -------- JAMES E. GUIRARD

RED CYPRESS AND OAK LUMBER

PHONES

AW MILL 3712

ESIDENCE 52

ALL DIMENSIONS ----- ALL GRADES
SAWED RIGHT -- GRADED RIGHT -- PRICED RIGHT
WE SAW OTHER HARDWOODS UPON REQUEST

SHINGLES
FENCE PICKETS

DATE	ARTICLES	CHARGES	CREDIT	BALANCE

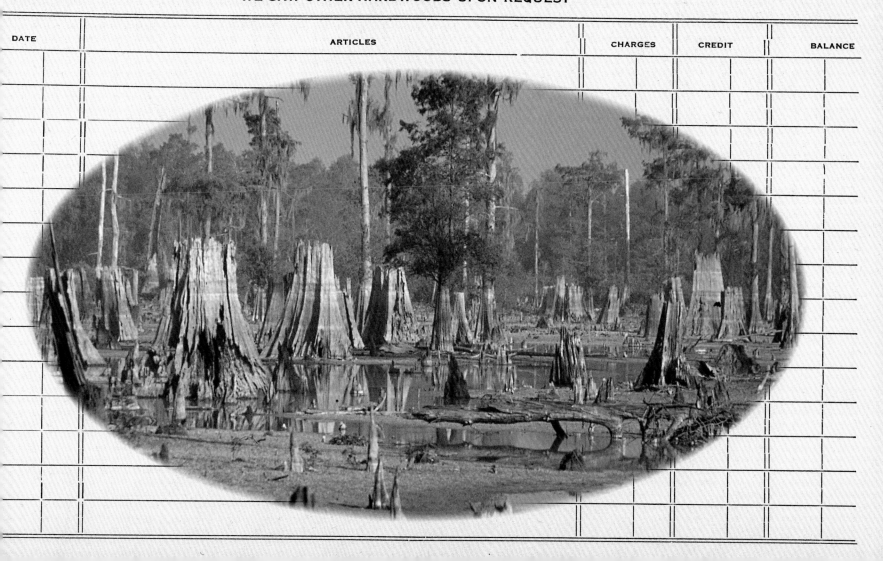

The following are excerpts from two letters written in 1847 by brothers who were great great uncles of my grandfather. The originals were in the standard French language. Balthazar Martin, author of the first letter, was at that time a state representative; and it was necessary, much to his distaste, for him to be in New Orleans. His longing for a simpler, more natural place is clear. Both brothers show a healthy disrespect for financial wealth, and a love of nature.

Monsieur A. Valsin Martin
Pont Breaux, LA

My Dear Brother,

....In your answer tell me if the trees have begun to bud out. Today at nine o'clock the weather is warm and beautiful and the sun which shines in my room with the chickens which I hear cackling in the yard mingled with the cooing of the pigeons remind me of home. Well, these are few moments when I am happy and especially when a neighbor with a sweet voice accompanied by her piano mingles with this harmony making it perfect for me, and if it would continue, I would spend the day well. But I am sure that in five minutes something will interrupt that, because that is happiness and I have never known happiness more than five minutes and I will pay for it for years. Exactly this is my concern–my rent must be paid today–damned city life where everything may be bought for money except virtue or common sense, of which there is none, for if there should be, it would have its price. And now I expect to have letters from you more often and by a good boat because mail comes faster, in three days.

I am your devoted brother,
B. Martin

Monsieur L. Balthazar Martin
Nouvelle Orleans, LA
Rue Toulouse #25

My Dear Brother,

....You find time long, I have noticed and I can well understand your position. You know man of all ages, in the past and in the future, is more unhappy than he is happy. Forgive me for making this observation, because in your last letter you sounded so miserable. Who is the one who can claim to be perfectly happy! The miserable one who does not know where to find bread to give to his children to feed them is less unhappy than the one who in an honest freedom searches, amid the strain and weariness, to amass great wealth in an amount much more than he now possesses....

But it is so late and everyone is in bed. I am going to bed also. Good night and keep well and don't be unhappy. When I had neither wife nor children I had few worries–not that I regret having married–that is far from my thoughts–but it is to know what will become of my children and of myself. Do you want me to tell you that I am always happy! Like everyone else I am happy at times. Nine o'clock is striking and it is time to go to bed. If I continue I will say foolish things. At present everyone is well.

I am your devoted brother,
A. Valsin Martin

From *Remember Us* by Lucien and Melba Martin, 1987
Used with permission of the authors.

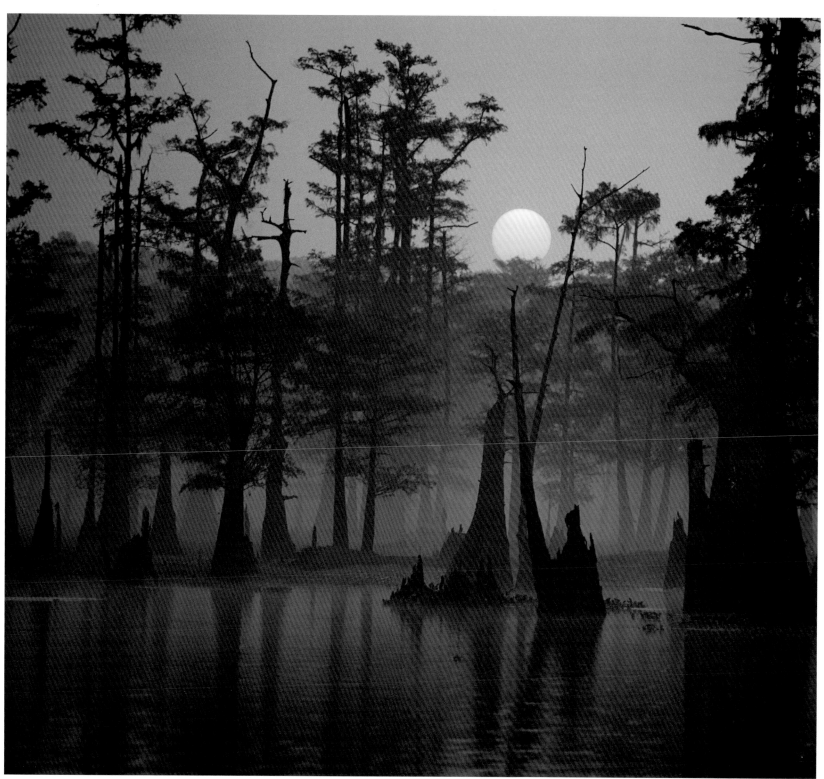

Sunrise near Bayou Benoit – September 1987

LAKE FAUSSE POINTE – NOVEMBER 11, 1994
Friday – 6:30 A.M.

Got up at five for coffee. Cool and windy, no fog, no sunrise.

NPR News: Assisted suicide OK'd in Oregon. Good. When are we going to begin allowing people to die, people whose time to die has arrived? Every time I visit my mother in St. Martinville Nursing Home, I'm left with the conviction that most of these people need to be allowed to die, if not helped to die.

It's a natural process; all living things have to die. Keeping them alive when their brains are nonfunctional and irretrievable, and their bodies are falling apart and a pain to endure–*that* is cruel and unnatural.

Why do we do it? Are we afraid that others will think or say that we are insensitive? If we believe in the afterlife, as we claim to, why won't we allow these near-dead individuals to continue their life adventure into the world of spirits? I doubt that *one* person who has reached the state I've described would choose to continue to "live." I say it here: If and when I become brain-dysfunctional and body-degenerate, don't just let me die; help me die! Don't help me continue to "live" in pain and misery. Spread my ashes in the Atchafalaya Basin.

Kurt Vonnegut is 72 today. Welcome to the Monkey House.

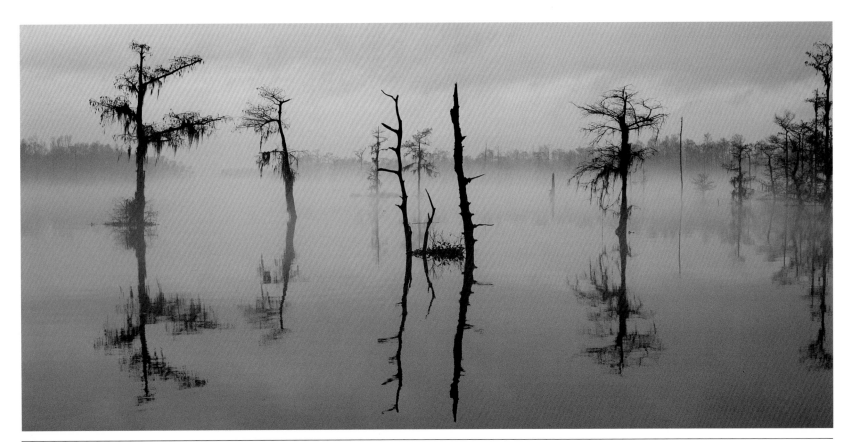

Foggy Winter Morning near Bayou Benoit – December 1992

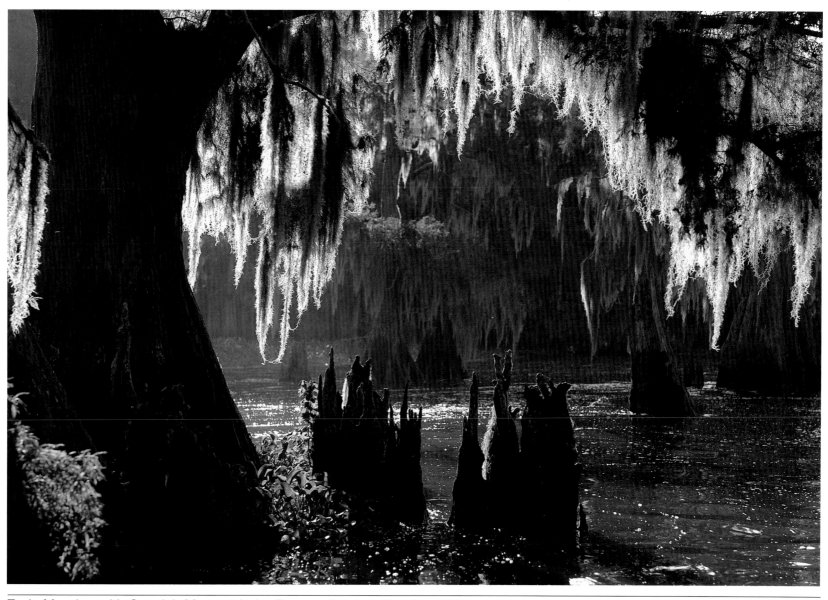

Early Morning with Spanish Moss at Lake Fausse Pointe – October 1993

In the mid 1930's the commercial harvest of Spanish moss in Louisiana averaged ten thousand tons per year.

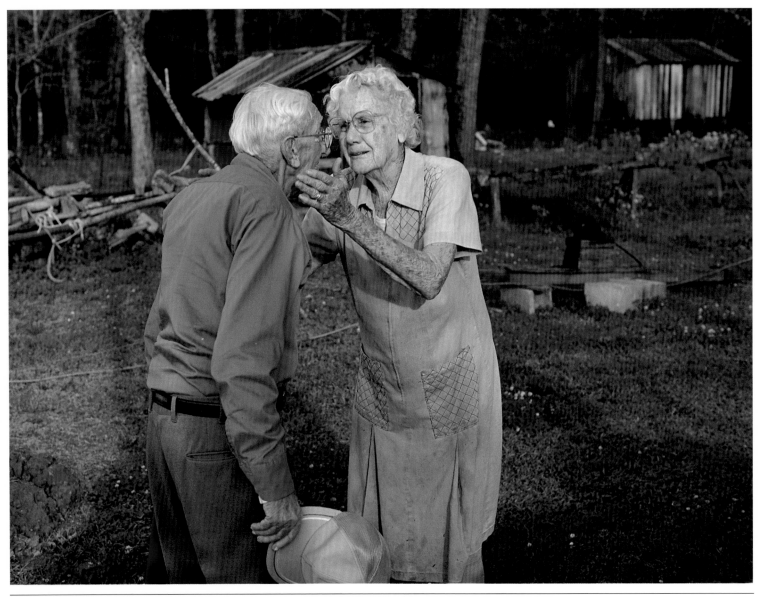

Myrtle Greeting Harold Bigler at Home on the River – April 1990

I wouldn't give up this life for all your town life. This is too much better...You get up
in the morning, you see the sun come up; you see the moon go down...

Harold Bigler, 1989

BAYOU CHENE – MONDAY, JANUARY 18, 1993
66°F. at sunset – River stage: 13.95 ft.

In 1963 I began teaching English at the University of Southwestern Louisiana, and in one of my freshman composition classes there was a bright-eyed young man sitting far back in the room. His name was Jefferson Caffery III, and it wasn't long before Jeff and I had become friends for life.

Jeff had a strong aversion to the phoniness in people. We read *The Catcher in the Rye* that semester and he got into that novel like no other student I've ever encountered. Jeff Caffery was the most openly generous person I've ever known, and he always said exactly what he meant.

"Big Greg," he said to me one day a year or two after he'd left USL without a degree, "I want you to meet some people I know who live out on the Atchafalaya River. You're gonna like 'em." And that was how I first met Harold and Myrtle Bigler. Myrtle is 93 now and lives there alone, since Harold died of lung cancer on Mother's Day in 1990.

Jeff Caffery did something else for me that changed my life forever: He gave me my first camera. A friend had paid a debt to Jeff by giving him a used Mamiya twin-lens reflex. He didn't know how to use the medium-format camera, so he gave it to me. I didn't know how to use it either, but by trial and error I learned. And I began to record on film the world that I love, the Atchafalaya.

Jeff Caffery died earlier this month at the age of forty-four, and he left this world with a speckled-trout fishing lure stuck into the lapel of his suit. Few things in life pleased Jeff as much as finding himself in a school of hungry speckled trout. Few things in life have pleased me as much as the friendship of Jeff Caffery.

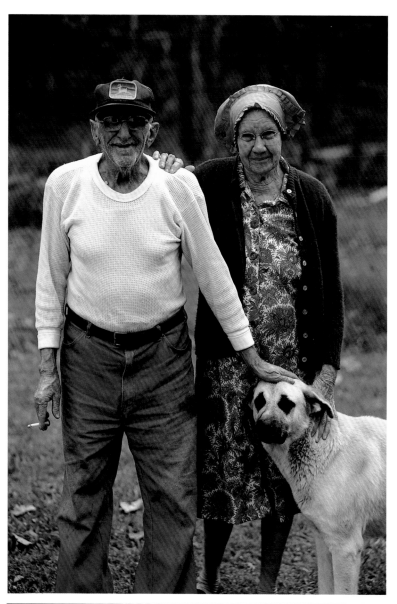

Harold and Myrtle Bigler with "Boxer" – Spring 1986

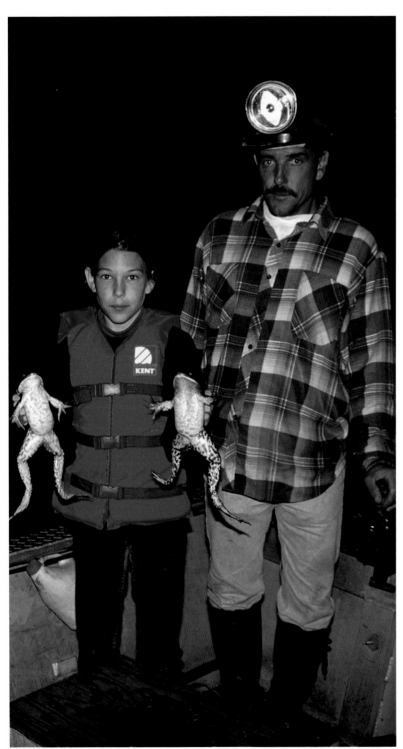

COCODRIE SWAMP – SHANE & DONNA'S HOUSEBOAT
June 9, 1994

This houseboat is only 15-20 minutes from the Catahoula landing by boat–and the landing's only two miles from my house. I can come here for an afternoon and a night and go home the next morning, getting the sunset and sunrise, day after day, if I choose. I'm only ten minutes from HaHa Bay, one of my grandfather's favorite old haunts. I'll try to go there tomorrow.

I had Agnes Blanchard's Spanish rice (with shrimp), and crawfish etouffée cornbread for supper, eaten from a hot skillet, as is my usual procedure. It went well with the rain and thunder of the last 45 minutes. The frogs quiet down when thunder booms, but not for long.

Forgot my coffee, so I'm having hot chocolate, an inferior substitute, in my mind. The water has been dropping fast for two to three weeks in the Basin; there are no crawfish being caught in the Cocodrie area now.

BAYOU CHENE – MARCH 30, 1993 – TUESDAY A.M.

Left the camp on Bayou Chene about 6 A.M. in a thick fog, got to the river to find an even thicker fog. Drifting down-river toward Myrtle's, I passed only forty of fifty feet from a tug (with barges, I guess). Couldn't see them at all; there was a good deal of noise, but visibility was limited severely. If the skipper saw me, it was only with radar.

Shane Doucet and Daughter, Kindall, Cocodrie Swamp – March 1995

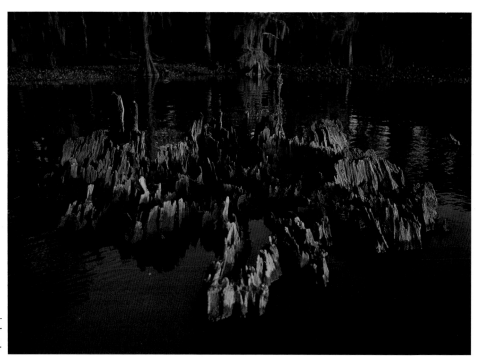

Cypress Stump in Lake Fausse Pointe –
November 1994

COCODRIE SWAMP – SHANE & DONNA'S HOUSEBOAT – June 29, 1994

Tried out my little two-speed, oscillating fan on a twelve-volt battery, for sleeping–it worked very well, helped drown out some of the sound of bullfrogs and tree frogs. If they quiet down a little, sleep may be possible.

Sometimes, when I look at the huge stumps all over the swamp at low water stage here and elsewhere I get really tired of thinking and saying to myself, "Man, this must have been something to see, all those enormous trees, before they were cut. What a place it would have been to walk in the fall, when the swamp is dry."

Sometimes I'd like to get my hands on the greedy, wasteful individuals who authorized and facilitated the cutting of these trees and let them know something of my resentment–the Louisiana state land office, the land company owners, the timber barons, those who denied me the sight and touch of even one healthy, huge cypress giant. *One* tree to raise my spirits, one tree to let me touch and gaze up at and walk around or paddle around, or under which to sit in the shade.

Recently I spoke to a man who has fished at Lake Fausse Pointe. He had gotten his 16-foot-long boat inside of a hollow cypress stump and fished there. We are so damned stupid, to have destroyed such a tree. Couldn't that one have been left to stand rather than to be cut down, sawed into pieces, and sold as boards and beams? *One*! Out of millions?

I feel a need to find that stump, get inside of it and witness first-hand the tragedy of the demise of the tree that it supported, the hundreds of tons of old-growth cypress towering into the sky, or the fog, or the raindrops, or the cold northwestern wind. I wonder whether these people ever understood the meaning of what they did. I wonder if any of us ever understands the things we do. Only at the last minute, while editing my own text, did I realize that this book should be printed on recycled paper. And so it is, but I very nearly missed that essential detail. Am I myself sleep-walking through life, rather than experiencing it deliberately? If I am, it's not through groves of towering cypress trees.

51

LAKE FAUSSE POINTE – NEW YEAR'S EVE 1994 –
6:15 A.M. (Transcribed from tape recording)

I'm in the water and there's a cup of hot coffee sitting on the gunwale of my welded aluminum boat. Waiting for a sunrise that's not going to happen. Just heard the first two shots–duck hunters–I've heard many ducks passing overhead, wings flapping fast.

Much more shooting. Gunshots resounding everywhere. I can hear somebody trying to call ducks. Every now and then I can hear more ducks flying over, some low and some high, in every direction. The legal shooting hours are 1/2 hour before sunrise until sunset–and I think somebody got an early start this morning. Other than the sound of ducks' wings and shotguns going off, I'm hearing two or three owls in the distance. It must be after 6:30 now. I've situated my boat behind some cypress knees sticking up between me and the direction of the sunrise–if there would be a sunrise–but it looks like the clouds are too thick in that direction. I'm only about a hundred and fifty yards north of my little houseboat. I can hear duck wings right now. There was another shot. Last time I was in the water here, there was a fine sunrise, with hundreds of white pelicans gliding over me.

It could be that those people shooting ducks this morning are fulfilling an old tradition that my grandfather always considered important–and that was to have game to eat on Christmas Day and on New Year's Day–whether it was venison, geese or ducks, rabbits or squirrels–it had to be wild game. There were always other things, too, like pork and chicken and all that–but the main part of each of those big holiday meals had to be wild game.

Shots are rolling in, especially from the north of me and the west. It must be fifteen minutes to 7:00–the ducks are still flying over. There is a little breeze from the north, and that may be why there's not much fog sitting around. The temperature is pretty warm–50 or 54°F. There's plenty of activity of fish jumping. I noticed that yesterday afternoon and again earlier this morning. I'm assuming it's catfish. So I'll have to check my lines in a few minutes. If the rabbit liver and cheese I put on yesterday doesn't work I'll have to go back to my old favorite, Spam® Lite.

There's frequent shotgun fire north of my position. I don't hunt anymore. I quit hunting maybe 30 years ago–25 or 30 years ago. I still understand the excitement, the thrill of the hunt–so I have no bad feelings about people killing ducks and deer. I don't think I could do it anymore myself–but many people that I love and respect are hunters. Maybe it's a way for those people to be living deliberately.

I think to live deliberately, as Thoreau meant it, must be to do something, on a regular basis, that allows a person to experience his senses consciously, and somehow *slowly*. I want to smell the food I'm cooking and taste the food I'm eating, and feel what I'm touching, savor the sounds that I'm hearing, focus on the things that I'm seeing, and to be always aware of the fact that I am a feeling and sensing creature and....I'm hearing two owls talk to each other right now, for example, and feeling the breeze on the skin of my face and hands–seeing the sky change color and the forms of hollow cypress trees all around me....against the grayness behind them, and....hearing the great egret right now and thinking about it, and a shotgun blast and a fish jumping–and not just letting those things pass unnoticed while trying to think about what I'm going to do later today or how I'm going to make a living, or what I need to do in regard to a certain person or persons....or activities, situations, or obligations.

It's like touching. Touching the water and feeling its coldness. Bringing my hand up against the breeze and putting it wet against my face, feeling its coolness and the nature and essence of it. (Shotgun blasts continue.) Hearing the echo from those shots. It's all living deliberately–being in touch with the earth and all of its characteristics–its sounds and its smells and its textures–feelings and images–and not just passing by quickly....or passing through without noticing....without touching or smelling, or without seeing or recording, as I do with my camera, or with my mind and memory. The opposite of deliberately is mechanically. I do not wish to live mechanically.

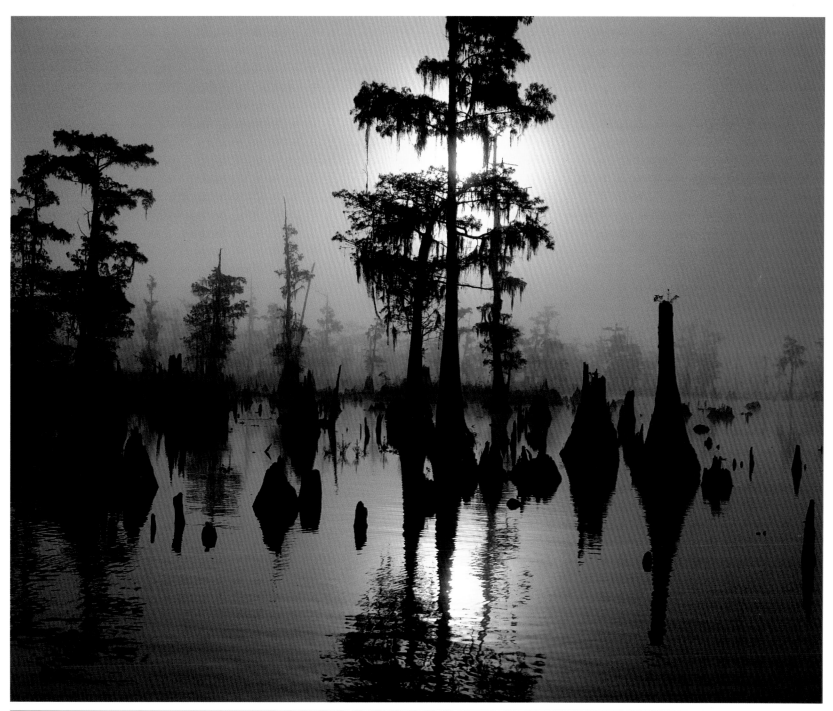

CBS Sunday Morning Sunrise, near Bayou Benoit – October 1991

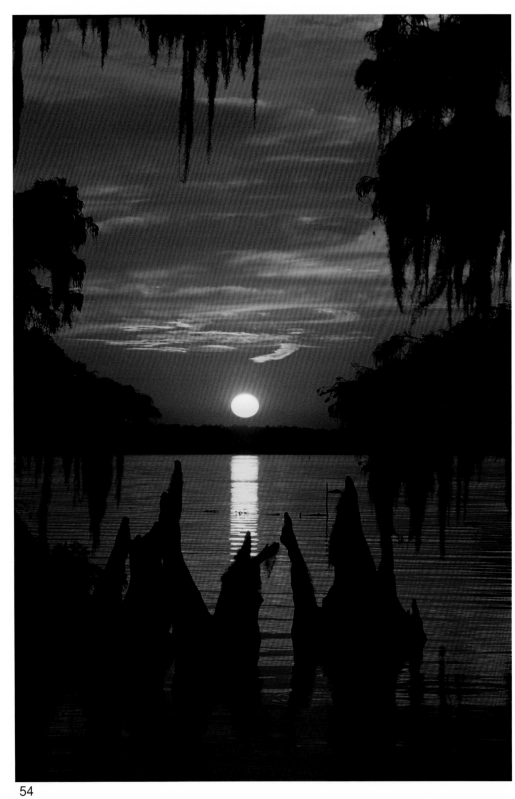

Sunrise at Lake Fausse Pointe – Fall 1989

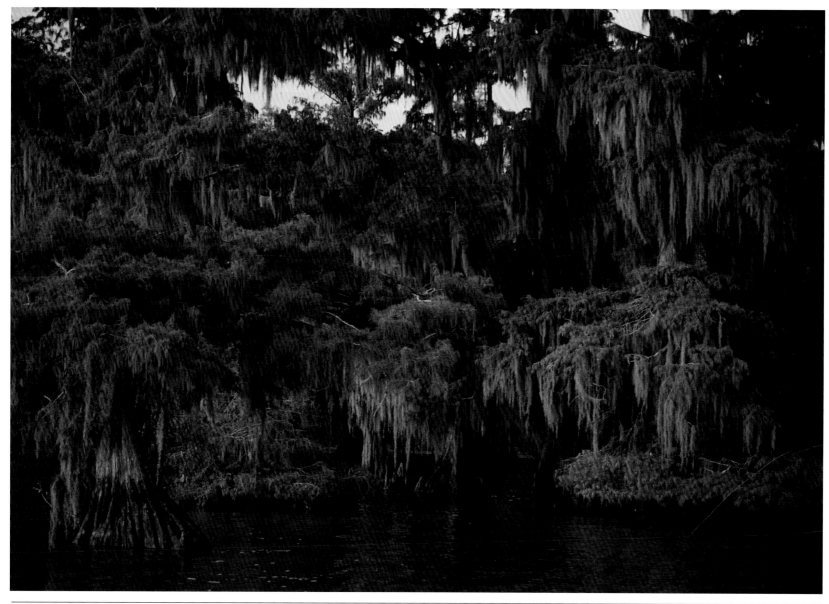

Cypress Trees with Spanish Moss at Lake Fausse Pointe – November 1986

...I don't want to have to content myself with a world where wildness has become a list of things that man can't change because he has not yet developed the technology–weather, for example–the coming and going of seasons–or the coming and going of day and night...

LAKE FAUSSE POINTE – NEW YEAR'S EVE –
1994, continued (Transcribed from tape recording)

I'm still hearing shotguns booming, but just now I've realized that I'm beginning to hear the sound of a distant train whistle. It's the ol' Southern Pacific that travels between Morgan City and New Iberia, several miles south of my houseboat at Lake Fausse Pointe. I can always hear it distinctly, early mornings and late afternoons, especially when the wind is from the south. And it never fails to call up from my past a memory that is thirty-seven years old now, a memory that is clear and present and one that I will always cherish:

One night in 1958 I was walking from the LSU Stadium after football practice–I was student manager–to the football dorm. My course took me by the auditorium, from which I could hear beautiful guitar music, since the door was open. I walked in and found a place to sit at the rear. The great classical guitarist Andres Segovia was sitting on a small straight chair at center stage, and he was playing music so fine that I was overcome, mesmerized. I had come from the noise and violence of football practice–it was the national championship season–into another world. Suddenly things were calm and peaceful.

Twenty or thirty minutes later Segovia was deep into another stunning piece before an audience that was mute with awe, when we began to realize that, in the far distance, we were beginning to hear a train. The night was very quiet, and the sound of the train grew steadily. Everyone at LSU knew where the tracks ran, right on the edge of the campus. While we hardly ever noticed the noise of the train at other times, this was an unbearable intrusion from the outside world. Segovia gave no sign that he even heard the train. He kept on playing as though the train were not really headed right at the auditorium, as it seemed to be. Then suddenly he stopped, as if in mid-note, and froze, his eyes fixed on the floor at his feet.

There was no sound but that of the long train passing, hooting and clacking by. The noise finally began to subside and to fade away at the same rate at which it had come upon us. Segovia remained as motionless as a statue of himself with guitar. The expression on his face had changed not in the least. When the train was barely audible, and everything and everybody inside and outside the auditorium was still, his fingers began to move, and the music flowed from exactly the point at which it had stopped minutes earlier. The auditorium exploded in mixed laughter and applause, and Segovia finally stood and smiled and bowed.

I believe that I will never forget the feelings and sounds and images of those few moments: the huge auditorium totally dark except for one light spotting Segovia on his little chair on stage, the extraordinarily beautiful sounds eminating from his fingers on those guitar strings, and a train that captured everyone's attention for a while.

Reflections from a Golden Sunset, SiBon Canal –
November 1984

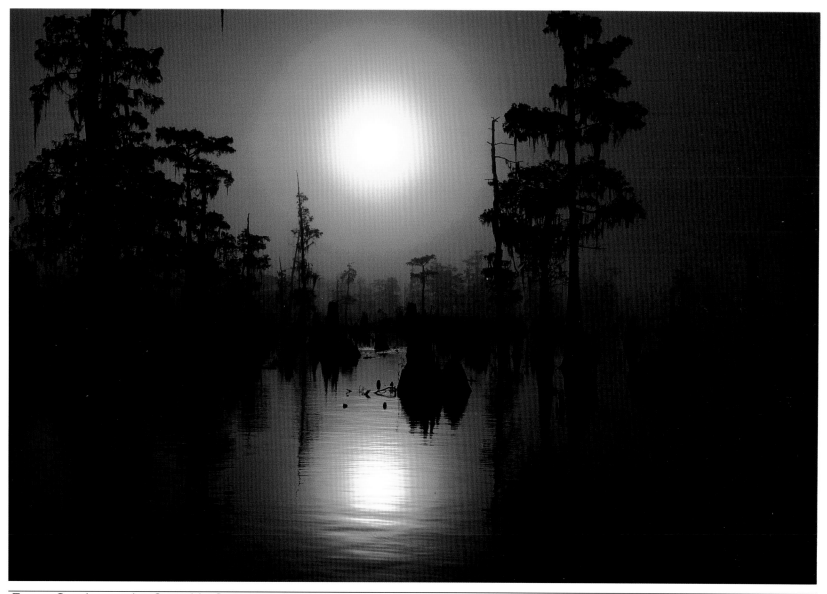

Foggy Sunrise on the Cocodrie Swamp – October 1991

Segovia remained as motionless as a statue of himself with guitar. The expression on his face had changed not in
the least. When the train was barely audible...his fingers began to move, and the music
flowed from exactly the point at which it had stopped minutes earlier.

Sitting on my houseboat listening to the radio, and the news today is the same as always these last few years–It's not so much what's happening and why it's happening and what it means, but what it will do to the popularity and political future of whatever politicians in America are connected in any way with the news event. Politicians are always running for re-election. Politics is rotten and insulting, and I am increasingly tired of it. Whenever any public figure says anything, his or her first concern has to be not the truth or wisdom of the statement, but how the "American people" will react to it. What do the American people know about the essentials of any major question being confronted by the government? Not much. Not even as much as the politically correct public officials.

Knowledge and truth and wisdom have little to do with what is said and done in government. The media are largely responsible. If the public has a right to know anything, it has a right to know the truth. Public officials who allow their words and actions to be controlled or influenced by the media are also responsible. Greed and selfishness and lack of compassion are the real problems. There are few public servants in America today. The system discourages their development and existence, as well as their rise to power if they do exist anywhere. To explain the title of *The Land of Dead Giants*, I wrote this:

Logging operations that removed all the big cypress trees from South Louisiana's Atchafalaya Basin had ended by the mid-1930's, shortly before I was born. At low water stage, from mid-summer through fall, there are huge stumps visible everywhere in the swamps. They are all that is left of the ancient forest of giant trees.

But the reference to "dead giants" goes deeper. The spirits of the big woods and the waters have been neglected, defiled, trampled under by the insensitive and destructive mentality of modern man. There was a time when the Atchafalaya seemed a refuge for those spirits and for people who revered them. It is less so today.

And finally, when we look at leadership in our nation, we see clearly that we are led, at every level, not so much by good men and women as by good politicians. Where have you gone, Thomas Jefferson? This whole country is a land of dead giants.

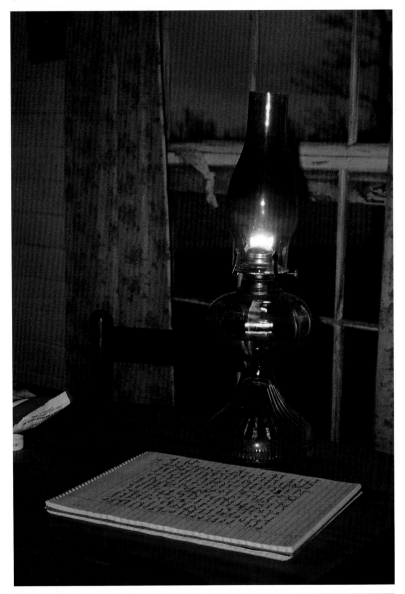

Writing by Lamplight in Camp on the Atchafalaya River – November 1993

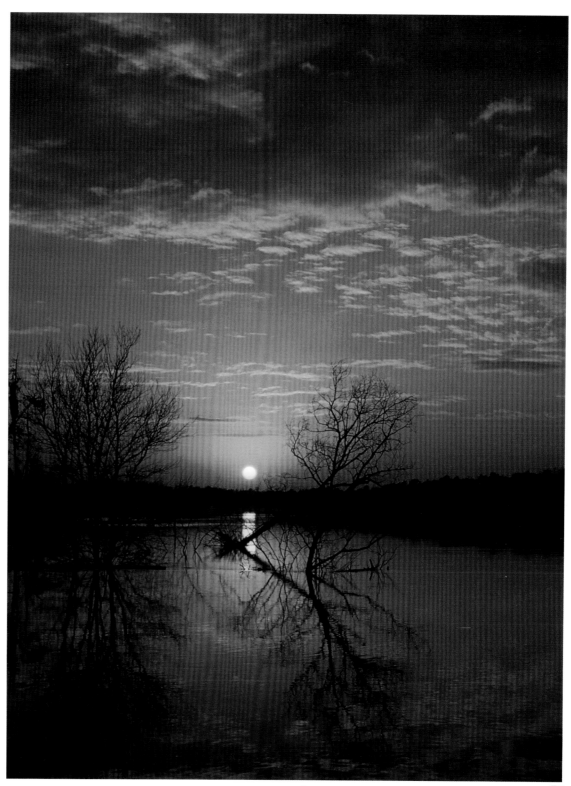

Sunset on the Atchafalaya River –
November 1989

ATCHAFALAYA RIVER – FEBRUARY 12, 1994

A strong wind kicked up around 4 A.M. and woke me. I was afraid that it might rain, because the rain frogs were making a racket, so I went out to the boat and brought all the wettable stuff inside. Now it's just barely light–it's cloudy and there's a silver-gray color to the river's surface, which is still pretty flat because the wind hasn't had time to rough it up much; but I suspect it'll be rough enough by the time I head back up-river and home. It's moving very fast. I just stood on the front porch and watched it–such a huge mass of water, moving by, rolling with currents on and under the surface, fast along the banks and much faster out toward the middle, though apparently slower. It's kind of mesmerizing to watch it–so much powerful movement, so seemingly organized–so completely quiet, like a huge army moving into position to attack, by cover of night.

I remember hearing stories from my grandfather of people living near rivers like this: One day you pull up a bucket of well water, and there's a small catfish in it. You get everything and everybody out of the house; that night or the next day everything caves into the river–house, well, outhouse, chicken coop and all. The river has undercut the bank and invisibly worked its way under the house and the well and everything–you should never have built your house on this outside bend. Now it's all gone, and if you hadn't caught the little catfish, you'd have lost much more than the buildings. Time to start over.

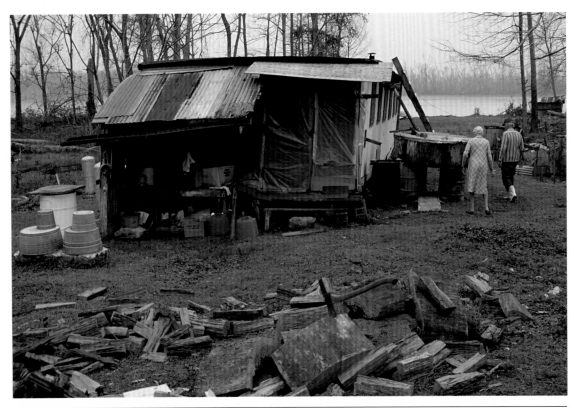

Myrtle Bigler and Taylor Lyle at Myrtle's House on the River – December 1992

I got icy river water in my right boot while washing the boots along the bank, so my right foot is freezing. The sock is drying on the wood stove and the pants and sweat pants are hanging from the ceiling above the stove. I'm about to make myself some cous-cous in a cup with instant Creole gravy mix thrown in, since I have no butter or craw-fish etouffée. Call me unprepared (no butter, no dry socks).

Myrtle's fixing pork chops and mashed potatoes for lunch. When I finish splitting firewood and eating lunch around 11 A.M., I'll leave for home, unless it's raining. I still have hundreds of trees to plant back there.

I just took my left sock, which is still dry and warm, and put it on my right foot, which is still freezing cold. My pants are drying very slowly, but I'm being patient. I think of ol' Siddhartha, sitting by his river, and I am content, albeit hungry. My spirit is content, though my stomach is relatively empty. But not for long.

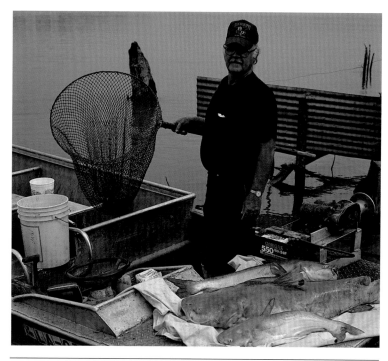

Sidney Horton, Jr., with Catfish, Atchafalaya River – October 1994

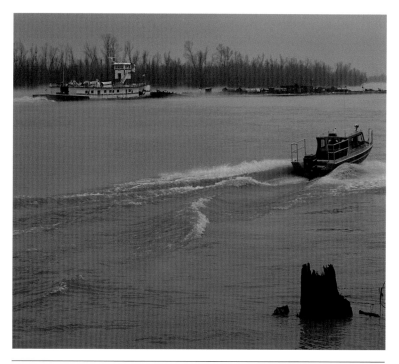

St. Martin Parish Sheriff's Deputy Leaving Myrtle's after Regular Weekly Visit – December 1994

Later: I'm afraid I've ruined my sock. The elastic material in it seems to be giving way as I stretch it over my formerly warm left foot. I must have melted the rubber in the fiber. Now my pants are drying (burning) on the surface of the stove. Henry David, I'm guessing that you would have dried your clothes more wisely. Of course, you didn't have to face a cold, hour-long boat ride home.

I saw two ospreys yesterday along the river and each had a fish in its claws. You'd think fish would be smart enough to stay deeper in the muddy river water when ospreys are around. Catfish especially seem to insist on their right to make a flip on the surface. And it's usually cat-fish that I see in ospreys' claws. So much for the rights of fish.

Red Sunset over Eagle Point – October 1994

There's something about being out in the swamp, especially when you're alone, that seems to suck the poisons of civilization out of you...some sort of healing power that...lets you begin to be yourself again.

Autumn Leaves on an Atchafalaya Basin Swamp – November 1992

Some things are difficult to understand. I went to sleep reading, a little after 7 P.M. About 9, I was awakened by the motor boat beating against the metal houseboat post to which it's tied, really banging. I'm thinking: oh, oh,– wind's picking up; there won't be any fog in the morning. Can't sleep with the boat banging, so I get up to tie it better. The houseboat is rocking gently in the waves that I assume are a result of the wind coming across the big part of the lake that fans out to the east, south and west. I step out on the back porch and am surprised to find that there's no wind. I mean *none*. The moss is hanging as straight and motionless as it does in a photograph. I tie the outboard boat with more slack and it floats a little way off, rocking in the waves. I go to the front deck of the houseboat and check the moss: no movement, no wind.

The clouds are low, so there is light reflected along the horizon, probably from various distant oil company installations. To the south there are beacon lights playing on the clouds. I assume they're from the famous gambling casino in Charenton, the Chitamacha revenge on white people. These are the lights that allow me to see that the moss is motionless, even at the tops of the big cypress trees. Inside the houseboat the pull cords on the lights and those on the roll-up window shades are swinging. I check again–still no wind. The waves are hitting the two big trees at the front and rear of the houseboat and splashing and gurgling against their trunks and the knees at their bases. I can see the outboard hull floating at the end of its rope, toward the north, as though the wind were from the south, but there's still no wind. Over a half hour has gone by since this started.

Temperature on the front deck thermometer–55°F. It's supposed to be 45°F. tonight. Almost 10 P.M. and the rocking seems to be subsiding a little. I'm afraid my food will spoil if it doesn't get any colder than this. I didn't bring any ice, counting on the predicted cold. I leave my food box on the back porch....still no wind....

About 10:45: The rocking has stopped completely; the outboard hull has floated back to where it was before the bumping started, away from the back porch, toward the south. The houseboat is oriented north-south, stern toward the south. No more waves, no change in temperature, nothing. I don't understand what has happened.

Once I was walking through a swampy area looking for interesting pieces of driftwood near a shallow bayou–a perfectly calm day. Suddenly I began to hear a violent roar over the water only forty or fifty feet away, lots of water noise. My first impression was that I was hearing a couple of big alligators fighting. I rushed to the water's edge and saw a fifteen-foot-tall column of water about two feet in diameter moving across the bayou with a kind of wave in front of it. There was a terrific roar. The whole thing was powerful, loud, quick and violent. I was so stunned that I neglected to photograph the scene before me, though I had a camera hanging from my neck, as usual. When the thing roared off through a swamp thick with trees where I couldn't see it anymore, I found myself standing at the water's edge with the pieces of driftwood I had been carrying still in my hands. What the hell was that? I thought. Everything was totally quiet again. All I could remember was that big column of water about fifteen feet tall, the wave moving before it on the bayou's surface and the deafening roar. I've never experienced anything like it since. This was in the Cocodrie Swamp, about 1976.

Jimmy Bourque, a commercial fisherman from Coteau Holmes, claims that around 3 A.M. one day when he was going out to his hoopnets on the river he saw a thing glowing on a tree branch along the bank. He didn't have his headlight shining on it, so he couldn't figure the source of brightness. He drove the boat close to the tree below the thing and found it to be a strange bird–glowing! It flew off back into the woods, still glowing, and he was unable to identify it.

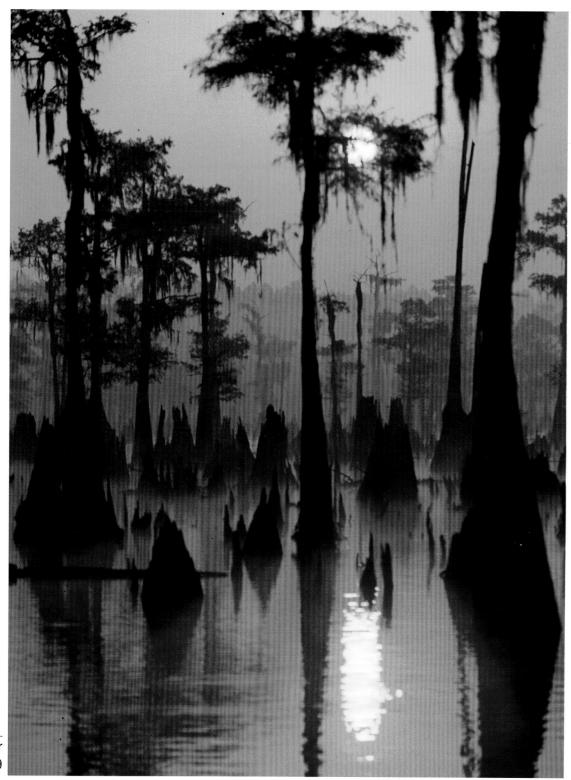

Sunrise with Ernie Bernard near
Bayou Benoit – October 1989

Early this morning the SiBon Canal was a trip. It's very shallow and very narrow, and I had to go full speed to stay "on step." If I had slowed down, the boat would have gotten stuck on sand, and I would have had to walk out for about three hard miles. But going that fast was dangerous, because it was almost too dark to see anything. Only the narrow strip of water in the middle of the canal had any light on it, and that's where the channel is that allows a boat to go through at all, at whatever speed. Three times I nearly hit beavers or nutria, or something swimming, things I couldn't identify in the near-dark.

It was only a few years ago, in the late '70s and early '80s, that I could travel easily down the SiBon Canal at any time of the year. It was my favorite place to go when the river was low in the fall, and the swamps were almost dry. So much sediment has built up in the last fifteen years that the canal itself is dry from late summer through the fall. This is a great disappointment to me. There seems to be no way to prevent the accumulation of sediment in the Atchafalaya Spillway. Eventually the fishing grounds themselves, as well as their access channels, will disappear under many layers of sand and silt.

Layers of Sediment along Alligator Bayou in the Atchafalaya Basin – September 1987

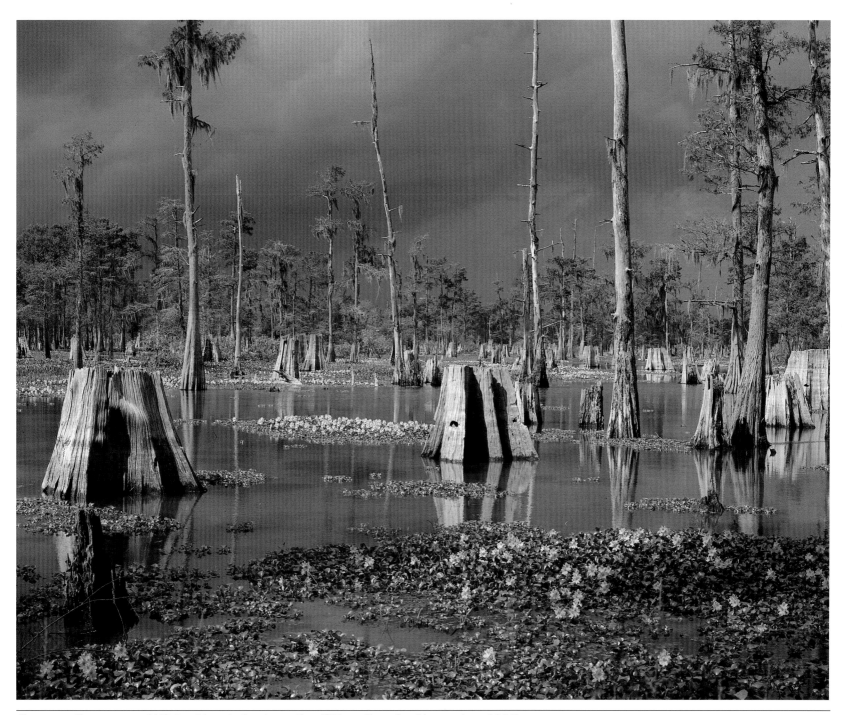

Cypress Stumps and Water Hyacinth along the SiBon Canal – November 1985

Recently I asked my friend A. Lee Foote about his work with the National Biological Service. I had read that the U.S. Congress is planning to cut that agency's funding by over 30 percent. At the same time I read in a weekly news magazine that the military budget includes many "billions of dollars for projects it says it does not need." The "defense" budget in our country, aided as it is by shameless levels of pork-barrel politics, trivializes everything we do with regard to protecting the environment of this planet.

The National Biological Service, if it is not devastated by budget cuts, can help us understand the world we live in and assist us in not destroying what is left of it. To add additional bombers and nuclear submarines to our already absurdly oversized military arsenal can do nothing but further endanger everyone on earth.

Lee Foote provided me with the following information. It includes some comparisons that leave no question as to what is important to decision-makers in this country and why the environment is in big trouble today:

"Since European man arrived on our shores we have lost over half of the wetlands that occurred in the lower 48 states. The greatest losses of coastal wetlands have been in Louisiana. To address such biological and ecological problems, the U.S. National Biological Service was created in 1994 by combining all of the biological researchers from the U.S. Fish and Wildlife Service, the National Park Service and the Bureau of Land Management to provide solid, unbiased information on ecological resources. The agency's annual budget is about 1/3 the cost of a new B-2 bomber. Yet proposals are on the U.S. Senate floor to cut $50 million from NBS' ecological research–a 1/3 reduction–and to increase the B-2 bomber program by over $500 million.

"Development and construction of one nuclear-powered Triton submarine costs more than has been spent on the operating budget of the U.S. Fish and Wildlife Service in its entire 55-year history. This speaks volumes about our country's priorities."

A. Lee Foote, Lafayette, LA

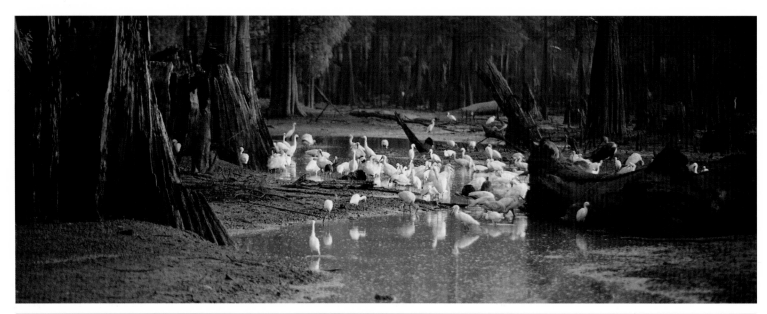

Egrets and Ibis Feeding near Bayou Benoit – August 1985

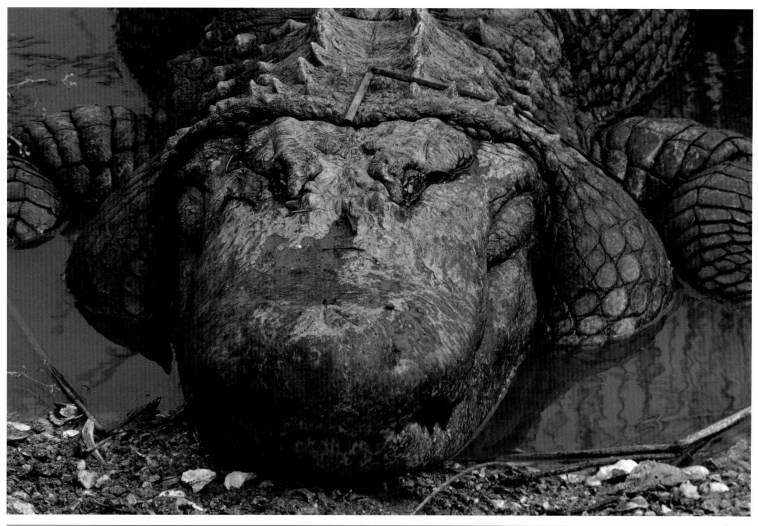

Thirteen-Foot-Long American Alligator – October 1988

LAKE FAUSSE POINTE – OCTOBER 21, 1994

Somebody stole my dog Paroona Monday morning near the barn. Nice Catahoula cur. Too bad. I had named Paroona after Myrtle Bigler's pronunciation of the name of a leading brand of dogfood. The population of people who will just stop and steal something continues to rise faster than the general population and much faster than the population of those who would never steal anything at all.

Making pan-style cornbread for supper. (There's no oven on the houseboat.) Malcolm X said, "A cat can have her kittens in an oven, but that don't make 'em biscuits." Good point, Malcolm.

Mmmmm. This is some of the best cornbread I've ever had. Ate it with butter and honey. I had added just a little brown sugar to the recipe, since I had no crawfish etouffée. Great with Community dark roast coffee. *Swell*, as Ernest Hemingway would say. But not *grand*. Don't ruin an experience by mouthing it up too much, he always said.

from: ODE: INTIMATIONS OF IMMORTALITY FROM
 RECOLLECTIONS OF EARLY CHILDHOOD

I

There was a time when meadow, grove, and
 stream,
The earth, and every common sight,
 To me did seem
 Apparelled in celestial light,
The glory and the freshness of a dream.
It is not now as it hath been of yore;–
 Turn wheresoe'er I may,
 By night or day,
The things which I have seen I now can see
 no more.

2

 The rainbow comes and goes,
 And lovely is the rose;
 The moon doth with delight
 Look round her when the heavens are bare;
 Waters on a starry night
 Are beautiful and fair;
 The sunshine is a glorious birth;
 But yet I know, where'er I go,
That there hath past away a glory from the
 earth.

 William Wordsworth

THE WORLD IS TOO MUCH WITH US

The world is too much with us; late and soon,
Getting and spending, we lay waste our powers:
Little we see in Nature that is ours;
We have given our hearts away, a sordid boon!
The Sea that bares her bosom to the moon;
The winds that will be howling at all hours
And are up-gathered now like sleeping flowers;
For this, for everything, we are out of tune;
It moves us not.–Great god! I'd rather be
A pagan suckled in a creed outworn;
So might I, standing on this pleasant lea,
Have glimpses that would make me less forlorn;
Have sight of Proteus rising from the sea;
Or hear old Triton blow his wreathed horn.

 William Wordsworth

from THE TABLES TURNED

One impulse from a vernal wood
May teach you more of man,
Of moral evil and of good,
Than all the sages can.
....

 William Wordsworth

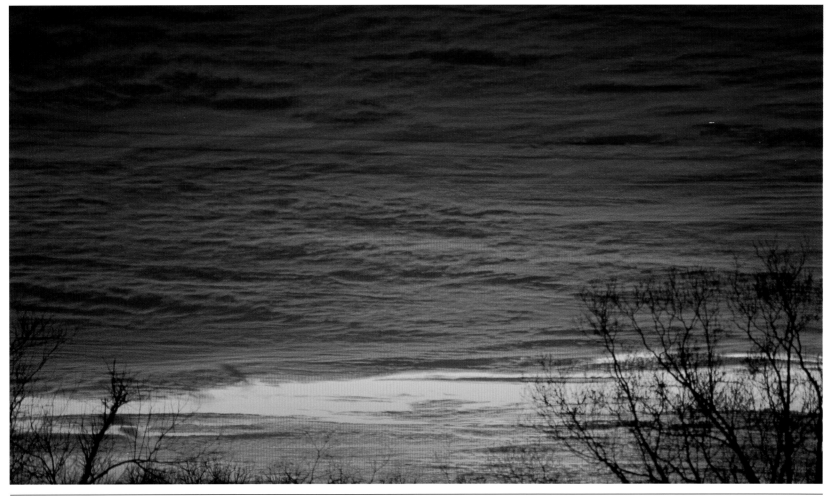

Sunset on the West Atchafalaya Levee near Catahoula – November 1994

LAKE FAUSSE POINTE – JANUARY 11, 1995 – Nighttime

Henry David, the world has been too much with me, but I'm doing a little of that living deliberately now. I'm lying here in my bed in the houseboat, looking out the window. The moon is bright–really bright–stars are out, too. But not nearly as many as on a dark night. There's a circle around the moon. Cypress trees everywhere have finally lost their leaves. Spanish moss is hanging there in the gentle breeze. I'm having a cup of coffee–just watched myself pour it slowly into the cup from my thermos–and a little piece of chewy gingerbread, which is good with coffee.

I'm just looking around and thinking, admiring the beauty of nature and realizing that my relationship with it is something good. That's all. In five hours I'll be standing out in the water somewhere with my leaky waders on and my tripods set up, seeing what I can do about the sunrise, and maybe even the setting of the moon, if I can get that at the same time. I just wanted to let you know that I've slowed down a little.

I was listening to NPR today, and the 50th anniversary of the fire bombing of Dresden, Germany, was being discussed. Dresden was a beautiful city of people and churches, museums and sculpture. Works of art were everywhere, and some of the most splendid creations of the human spirit were to be found there. Many felt certain that the city would be spared destruction because it had no military significance and because its culture, architecture and art were known everywhere. They were wrong. Everything was destroyed one night in 1945. Civilian deaths exceeded 130,000.

Novelist Kurt Vonnegut was there as an American prisoner of war, and his *Slaughterhouse Five* contains an account of his experiences in Dresden during the time of devastation. I've often wondered whether the cynicism that characterizes all of his novels and short stories is not somehow a result of his having witnessed, as a young man, the acts of war that reduced so much life and beauty and so many irreplaceable works of the human spirit to burned-out rubble.

I wonder too if we can stand by helplessly and witness the devastation of the beauty and essence of the natural world around us without suffering some of the same kind of damage to our individual and collective spirits, consciously or unconsciously. Everywhere we look, it's happening: Air and soil and water are being polluted; old growth forests are being cut down; woodlands in populated areas are being replaced by office buildings and shopping malls and parking lots. Who is looking out for the human spirit while these things are happening? Why are greed and waste so consistently more powerful than the love of the natural world, the earth itself?

It seems almost inconceivable to me that all of the great cypress trees were cut down, without protest or opposition of any kind. There must have been someone, I keep thinking, with the sensitivity and awareness and wisdom to recognize the need to preserve some of those magnificent giants for their own time and for future generations; someone who would stand up and say, "Hey, you can cut some of the big trees, even most of them, but you can't cut down every last tree. I live on this earth, too. It's not yours to destroy."

Apparently nobody stood up and said anything like that. Now it's much too late. I try to imagine, from time to time, what it would be like to walk through a forest of giant cypress trees–tall, straight columns of living wood, close together, towering above me and forming a canopy like the ceiling of a great cathedral, shutting out most of the day's brightness, creating a magic, ethereal twilight even at midday. I long for that impossible time and place.

To rob mankind of that experience was a crime against humanity, a crime against the environment, a crime against beauty and truth. We are all its victims, both the living and the unborn. The criminals were never punished, never even arrested, charged, or prosecuted. As William Faulkner sought to have us understand, we are compelled to live in a world that we create ourselves, or that we allow others to fashion for us with their greed and wastefulness. We need to do better.

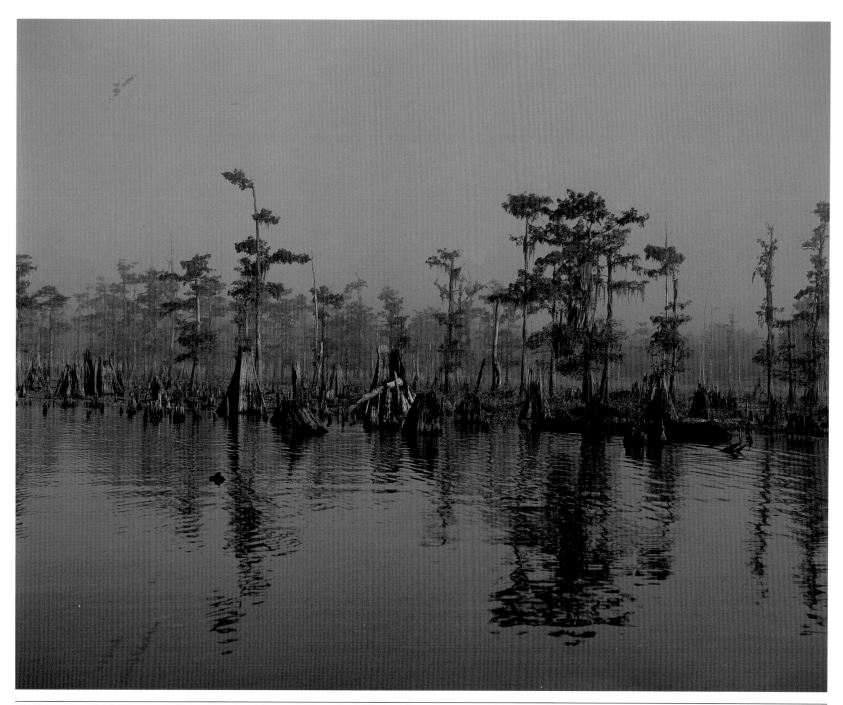

A Graveyard of Cypress Stumps near Bayou Benoit – November 1984

The finest qualities of our nature, like the bloom on fruits, can be preserved only by the most delicate handling. Yet we do not treat ourselves nor one another thus tenderly.

The mass of men lead lives of quiet desperation. What is called resignation is confirmed desperation. From the desperate city you go into the desperate country, and have to console yourself with the bravery of minks and muskrats. A stereotyped but unconscious despair is concealed even under what are called the games and amusements of mankind.

Let us spend one day as deliberately as Nature, and not be thrown off the track by every nutshell and mosquito's wing that falls on the rails.

Why should we be in such desperate haste to succeed and in such desperate enterprises? If a man does not keep pace with his companions, perhaps it is because he hears a different drummer. Let him step to the music he hears, however measured or far away.

Henry David Thoreau

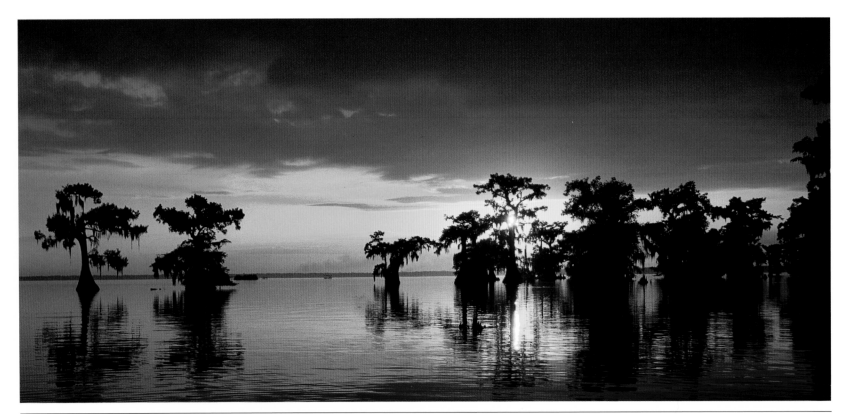

Cloudy Sunset near Peche Coulee, Lake Fausse Pointe – October 1994

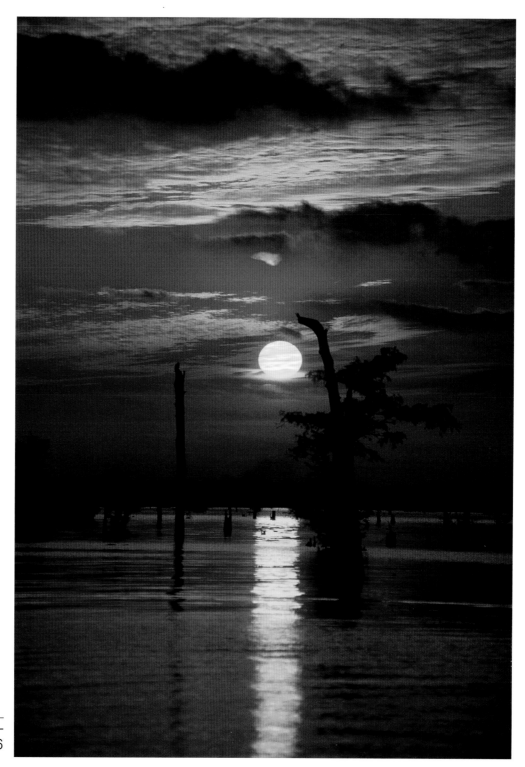

Sunset on Henderson Lake –
December 1986

LAKE FAUSSE POINTE – OCTOBER 25, 1994
Tuesday – 7 P.M. – Temperature about 70°F.

About 5 P.M. today the water was calm and flat; there was good light, good reflections. Not a person was in sight, nor in hearing range.

Soon after I got here, I baited several branch lines with shrimp, trying to catch a catfish or two or three. There was a big ol' barred owl watching me bait one of the hooks. I got closer and closer and he just looked, unafraid. I threw some shrimp to him, but they fell into the water. Then I put three of them on a branch a few feet under him, but he ignored them–kept looking into my boat, as if to see whether I had anything better, like a small fish, I guess. I photographed him repeatedly, finally using a flash, when I was only ten feet from him. It's strange how some species, and some individuals in that species, show no fear of people.

Anyway, I thanked the owl profusely for his trust in me and promised him (or her) a piece of catfish tomorrow. Hope I can deliver.

The hum of mosquitos outside my houseboat is so loud that I can hear it distinctly over the sound of music from my radio, whenever the volume is low or when there's a pause. It's unbelievable. The screen in front of me is about 2 x 2 1/2 feet in area, and I can see what appears to be thousands of mosquitos on it. They're on top of each other. The air behind them is a maelstrom of mosquitos. There is a kind of whining sound everywhere.

Suddenly a wind has begun to blow; the houseboat has begun to rock. In the space of two minutes time, the wind has gone from perfectly calm to breezy, with strong gusts. Cold front is moving in, I guess. I should have taken my cameras in from the open boat, but I'm surely not going out there now; the mosquitos would feast on me. If the wind blows hard enough, maybe it'll blow the mosquitos away before the rain begins, and I can get the cameras. Only two are in waterproof cases.

I love to be out in the woods or on the water when there's a big change in the weather, especially from hot to cold. There's something exhilarating about a coming storm, cold front, whatever, even a hurricane. I didn't bring any warm clothes on this trip. Forgot about the cold front until I was putting my boat in the water at Lake Dautrive, six or seven miles north of the houseboat.

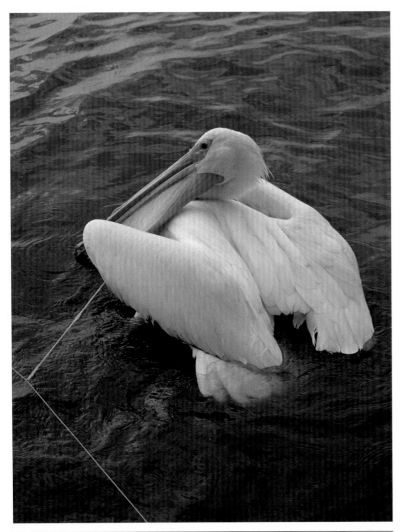

Pelican Hooked on Catfish Line, Lake Fausse Pointe – November 1993

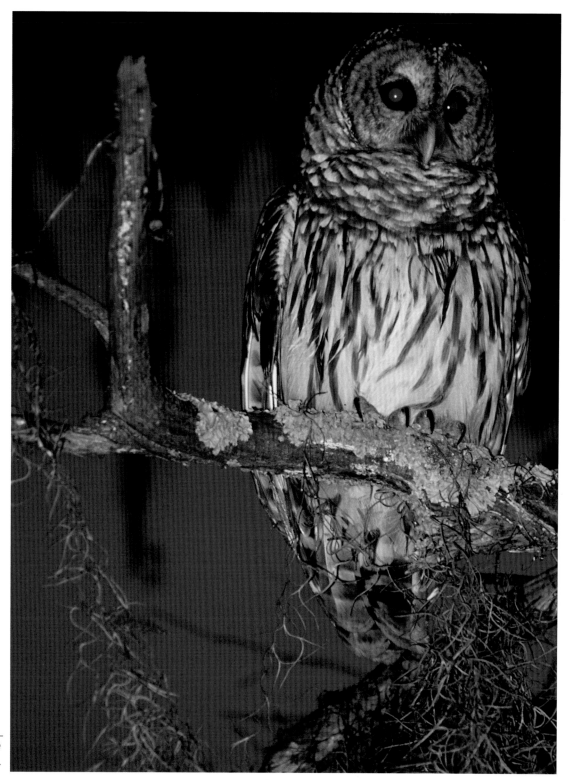

Barred Owl in Cypress Tree, Lake
Fausse Pointe – October 1994

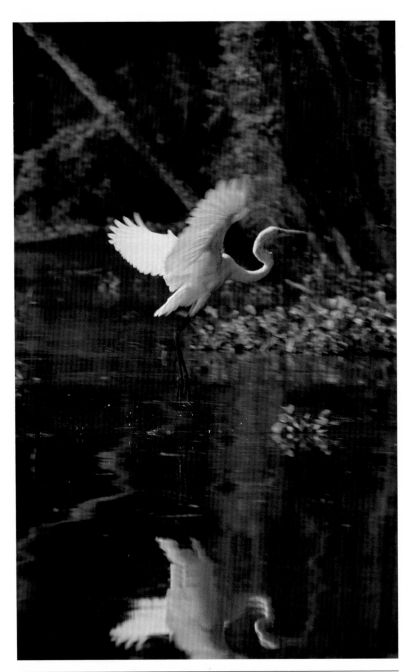

Great Egret at Henderson Lake – September 1991

I have a first cousin named Toni. She and I share a grand-father, now deceased, and a love of trees in particular, and Nature in its entirety. I asked her recently to write some-thing for me regarding her feelings about trees:

As a child, I had a secret prayer: I prayed that the Great One would allow me to melt into the waters of the river, from where I would be sucked up into the sky to become a rain cloud, to then travel upon the winds to some far-off land, to be dropped upon the leaves that made up the canopy of a woods. There I would drip from leaf to leaf, lit-tle by little being drawn into what I believed to be the great-est living thing on earth, the tree. There, as a part of the woods, as part of a tree, I would become part of the great-est source of energy in all of Nature.

Toni Svendson deBosier

Any fool can destroy trees. They
cannot run away; and if they could....
they would be....hunted down as long
as fun or a dollar could be got out
of their bark hides....Through all
the wonderful, eventful centuries
since Christ's time—and long before
that—God has cared for these trees....
but he cannot save them from fools—
only Uncle Sam can do that.

John Muir
1838–1914

78

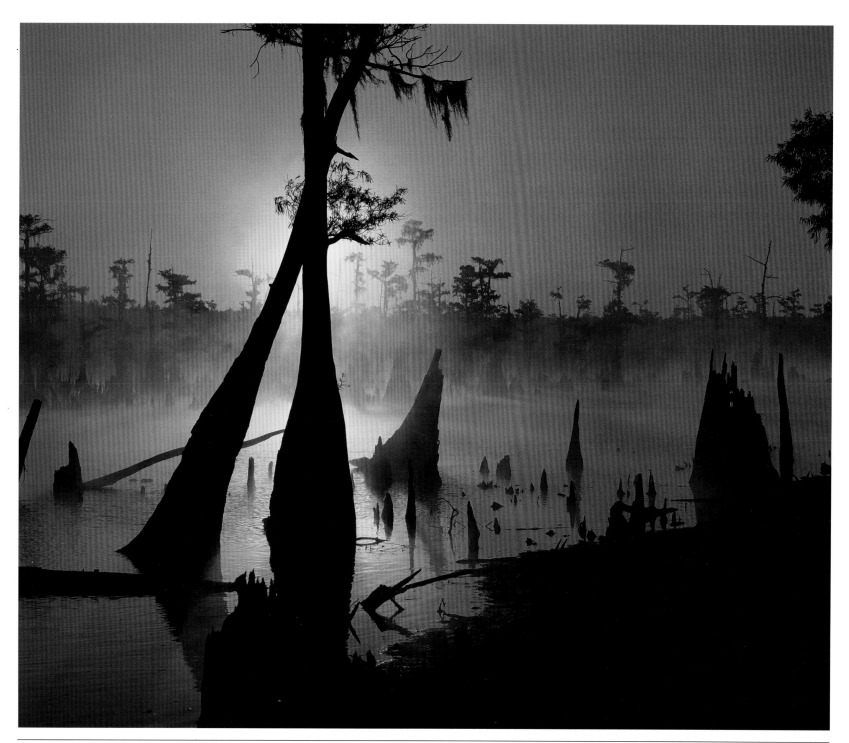

Red Sunrise in the Cocodrie Swamp near Benoit – November 1990

CATAHOULA – AT HOME – MARCH 13, 1995
(Transcribed from tape recording)

It is five minutes after 2:00 in the morning on March 13th, and I'm sitting here on my sofa. I just read a piece in *Audubon Magazine* (March/April 1995) by Barry Lopez concerning himself and his wife and the thirty-five acres of woodland they live on somewhere on the McKenzie River in Oregon. And it's very sad to me. It's–what he's talking about mostly, in this piece, it's not so much his love of nature that comes through very clearly and always has, in his writings, but the whole picture I get of what his life is now that it's some kind of effort on the part of himself and his wife to shield this one little piece of land that they seem to love very deeply, from the intrusion of people around them who don't have the sensitivity, who can't see the

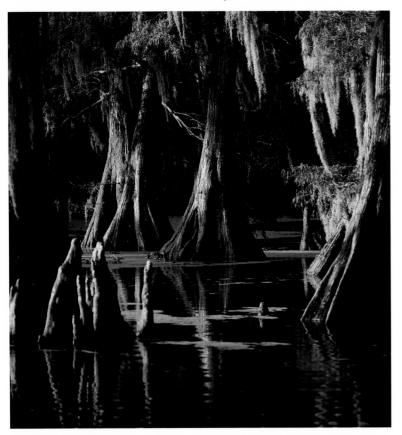

Cypress Trees in Sandy Cove near Bird Island Chute –
February 1989

beauty that Lopez finds in this land and the trees and the birds and the animals, and therefore are destructive and wasteful and break down the world around us into something that makes them somehow more comfortable or allows them to feel they have progressed because they can develop a piece of land and make it less wild. He refers to it as the bereavement he feels at the diminishment of life around him.

This is very sad to me because it seems that it's not just that there are too many people, although that's a very big part of it, I think. It's that so few people still, in spite of environmental movements and organizations and information about what's happening to the world we live in....It's like, what's the use? The people who have a deep reverence for what was there before we started changing it have no authority or power–it's like we're talking primarily to ourselves, and each other, rather than to those people who have no interest in listening or who are specifically opposed to listening to the kind of message that says the earth is beautiful the way it is....we don't need to change it, profit from it, develop it, make it over into our own view of the way things should be. It's beginning to seem hopeless. It's that Lopez's life, and to a certain extent, my life, and the lives of all the people who revere Nature, who find our spirits elevated by something that thrives in the unaltered wilderness, if we can ever find any of that–that we spend a good deal of our energy and–oh, what's the word I'm looking for? We spend our lives trying to live in certain ways that–it's obviously difficult to verbalize what I mean....

We're always out there–it's like a full-time job–defending not only the wilderness itself, but our feelings about it. We can't just–just enjoy being in nature and photographing it as I do or writing about it or simply experiencing it–we've got to be defending it all the time, against people who don't see it–who don't see it the way we do. It's almost as though we are in love with–like a person who's in love with someone that he's afraid or she's afraid somebody else will come along and take away. It's like we have no way of–no real–there's no peace. There's no eventual satisfaction that....that someone lurking around the corner is not going to destroy what we have or what we love.

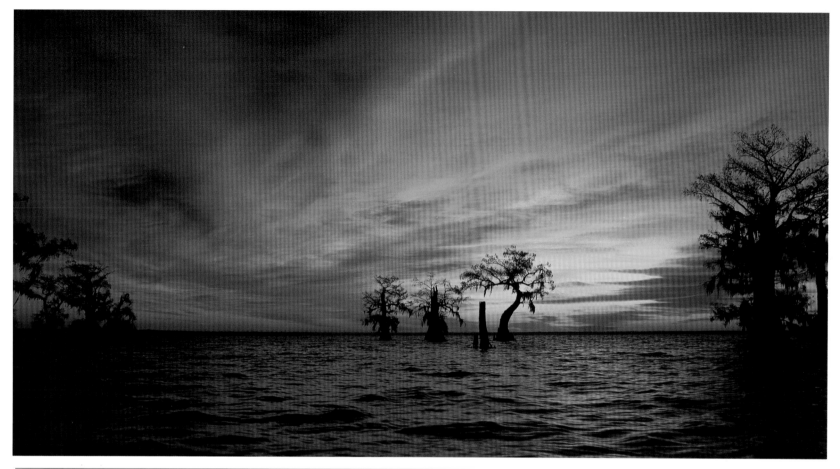

Sunrise from West Bank, Lake Fausse Pointe – Fall 1993

We don't have to own nature, anymore than I, in any real sense, own the land on which I've planted 40,000 trees. I don't know what it is I'm doing. It's just that I want to leave something–I want to walk among beautiful trees and in quiet places and down paths that I've made among the trees that I plant every year. I want my children to be able to do that and I want strangers to be able to stop their cars next to the land where I've been planting trees, and walk down the paths that I've established, and it's like if there's something a person can do of value in the world, it's to attempt to....make other people feel good or benefit from something we've created, or just protected, in some cases.

It was my grandfather who–whom I admire so deeply, who would never let the sugarcane farmers or any- body cut down the big live oak trees that were growing here, even though to pay for this land he had bought he felt compelled to cut down many of the trees himself–not the live oaks, ever, but the other trees he and my father cut into lumber to sell for–to pay the land debt. So those oaks are still here, and the rest of the trees on this place are the thousands that I've planted and that won't be trees of any great size during my lifetime, but they will be during the life- times of my children and grandchildren and their grandchil- dren. But there's no other place anywhere around here– anywhere among any of the people that I know or the areas where I travel–where anybody is planting trees except as ornaments to their beautiful new homes or to their lawns or whatever, or to be harvested for profit.

I don't know what it would take to encourage other people in this area to use some of the land they own for planting trees instead of for producing crops or housing developments or whatever it is they feel a need to produce. I don't know what can be done. I'm not even trying. If I can plant trees on my land and they grow and people admire the beauty of them, then maybe someone else will say, "Well, that's really nice—maybe we should plant trees on some of our land."

I don't want to be....I don't want to have to live the kind of life that Barry Lopez is living. I don't want to have to be here to defend this land from chain saws and developers and—this is no spectacular piece of beautiful land in itself—it's not a place that has snowcapped peaks as a background and a wild, rushing, clear-water river as a foreground, or anything like that—but it's a nice place, anyway. And I don't own the land anymore than the Native Americans thought of themselves as owning the land they walked on when they inhabited these areas and all the other areas they occupied across the continent, although the title is in my name.

I don't know what I want. I want people—I want everybody to feel that....To what? Recognize beauty, value beauty, recognize some right the *earth itself* has that overrides the rights of people or society to destroy it or to develop it or to progress, somehow, by diminishing it.

I remember from reading Faulkner that he also felt that way about ownership of land. I believe that he mistrusted the idea of private ownership of the earth. It seems that for individual human beings to own the earth, makes no more sense—Faulkner didn't say this; I am saying this: It makes no more sense than for us to conceive of bears owning the land or deer or God or the business world or government or whatever.

Faulkner seemed always moved by those aspects of Nature that were beyond the reach of man—or at least that we've always conceived as being beyond the reach of man. Like the coming of day and the coming of night and the change from one season to another, from one year to another, the winds and hurricanes and tornadoes and rainstorms and tides and bright or cloudy days and dew on the grass and fog over the water and all the things that man does not, cannot—hmmm—I have to say yet, I suppose, cannot yet—does not yet, control—alter to his requirements.

But I don't want to have to content myself with a world where wildness has become a list of things that man can't change because he has not yet developed the technology—weather, for example—to alter the coming and going of seasons—or the coming and going of day and night—or the cold that comes with late fall and winter, or the warmth that comes with spring. It's not that all these things are not important to me. They are *essential*. But they are only part of what I value in Nature. I don't want to be backed into a corner of having only these unalterable characteristics of the natural world to rely on. I want big trees. I want quiet places to walk. I want bayous flowing through swamps,in the way that bayous used to flow through swamps 200 years ago....500 years ago....even 100 years ago. I want to know that there are big fish in the water and that there may be a panther lurking somewhere in the woods....and I want to know that there are some parts of the swamp where nobody ever goes....almost as though people don't consciously know that such places exist—and not even because I want to go there myself. I just want them to be there. I'm afraid they don't exist anymore. If I never see the coastal redwoods and giant sequoias, it still pleases my soul to know that they are there.

Oh, I know that people have to make a profit. I know that if a company—like the big land companies that came here after the Civil War—buys or somehow takes possession of an enormous piece of land with valuable timber on it—profitable because those trees can be translated into extremely marketable lumber—that they're not going to let the trees sit there, grow there, stand there—uncut, unharvested, unsold.

But I long for a world in which people of power or wealth would value the serenity and beauty of Nature as much as some of the people who don't have power and wealth and the desire to profit from the demise of Nature, the way that the timber company people did when they cut down every last cypress tree and ash tree and whatever other trees were growing out there, in the Atchafalaya–to transform those trees into lumber that they could sell for a profit.

I want to avoid the despair that comes from my recognition of the fact that–that the wilderness is going to be destroyed. I know that pockets of wilderness will exist for a long time, but they will be pockets of wilderness–or semi-wilderness–or reconstructed wilderness–I don't know how–I don't know how to deal with that eventuality. I don't want to be a cynic. I know that there are thousands and thousands of people who feel about the earth the way I do, and who feel even more than I can feel. But for the most part, they are not people who have the power or the motivation or influence to have their voices heard by those people who don't feel that way, who don't revere the earth, who revel in the change and the development and the progress, as they see it, in conquering those undeveloped wild or semi-wild places that still exist–or invading them and trashing them and taming them.

It doesn't seem to me that those are people–and they seem to be in the majority–who can be influenced to stop and look around and realize the things that I, and others like me, want them to stop and see and realize. It's just not gonna happen. It seems that, from the first–when this country began to be inhabited by white people, white Europeans–that the destruction was already inevitable and the invasion of helpless Nature was going to succeed for the invaders, and that the inheritance of those who came after would be an altered landscape. A terribly altered landscape. A tragically....what am I trying to say? That what was here before–the big woods and clear streams and clean air are going to have to–were destined to–be changed into whatever they have become: highways and parking lots and developments, dirty air and office buildings, cities and polluted waters, bridges and business establishments

of various kinds, and that....it's impossible for me to say what I mean, what I'm feeling. I'm trying to reason something out here that sounds like I'm saying big woods and big trees are more significant or valuable, somehow, than the activities of mankind. And then I would have to say–more significant or more valuable to whom? To themselves, or to mankind itself? Was the world created to satisfy the idea of itself? To–to provide man with–was the world created as some kind of backdrop for human activity or for some essential reality that we don't even understand? Or for any particular purpose at all?

I'm not trying to judge people–it's not my right or my power. It just makes me sad to see somebody like Barry Lopez having to defend the beauty and natural integrity of a small piece of the earth against his own neighbors.

Baby Red–Shouldered Hawk Eating Crawfish

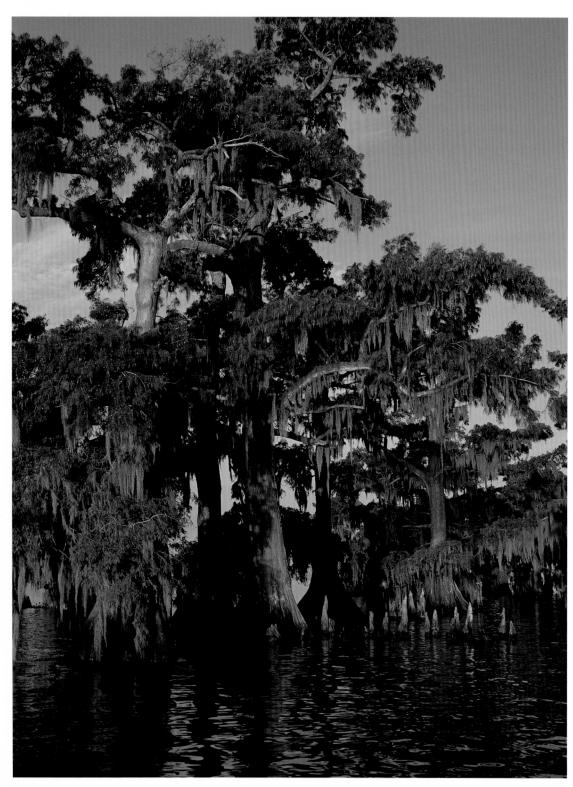

Old-Growth Cypress Trees with
Spanish Moss at Greg's Point –
October 1994

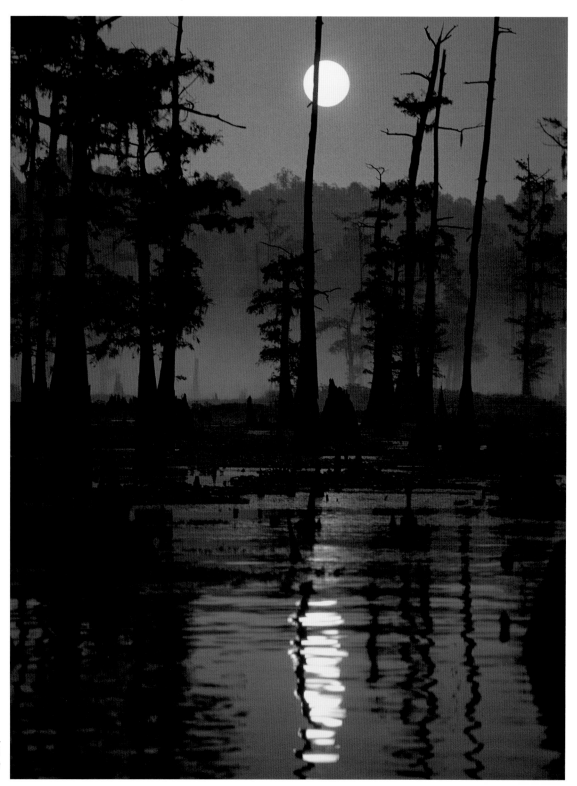

Sunrise with Silhouettes near Bayou
Benoit – November 1987

CORPS OF ENGINEERS
–an opinion–

With regard to the U.S. Army Corps of Engineers, I would have to say this: The Corps of Engineers has made some serious mistakes, but certainly not with bad intentions. There were no models to work from, no precedents: You don't find systems like the lower Mississippi River and the Atchafalaya Basin in ten or twelve other places in America. There have been few reliable factors available to help guide the engineers in their work.

Trying to control and direct powerful forces of nature is not an easy matter, and to do so without unfortunate side-effects is probably impossible. To criticize the Corps as many people here do, I believe, is counterproductive. I think that their efforts to avoid destroying the fishing grounds while maintaining flood protection are sincere. I think the Corps is doing the best job possible under very difficult conditions. I sincerely hope that they succeed, especially in their efforts to control sedimentation in the lower spillway. Only the Corps of Engineers can extend the productive life of the waters of the Atchafalaya Basin, if anyone can, and they should have our support and assistance.

Old River Control Structures and Hydroelectric Plant at the Head of the Atchafalaya Spillway, Facing South – Mississippi River on Left, Atchafalaya System on Right – February 1995

Sunset from the West Atchafalaya Levee near Catahoula – December 1994

CATAHOULA – DECEMBER 4, 1994

The sunset Thursday was spectacular–an easy 10. By the time I saw it developing, it was too late to get to Lake Fausse Pointe or even to the Lake Dautrive landing and shoot it over water, so I went up the levee about a mile from my house, set up my cameras and did the best I could. Wish I'd had a video system to put on a tripod and just allow to run, recording the changes in color and shape–the reds, pinks, golds, the ever-changing forms.

If a sunset happens and no one sees it, did it create an image? If a tree falls in the woods and no one hears it, did it make a noise? What if the tree heard itself fall? Or felt itself fall? What if the earth heard the tree fall? What if the sunset enjoyed its own glory? How much do we really know? How much do we *really know*?

Handguns and Hushpuppies

You're halfway through the catfish special
At the Cock of the Bayou,...on Bayou Amy,
When a shot rings out;
But not rings at all–pops–
In the barroom only a half-glass wall away.

A girl runs in to where you sit,
Catfish in your left hand, Coke in your right
 "They shot 'im!"
 "He shot Dean!"
 "Where's the Chief?"
You don't believe it yet.

 "Somebody call the ambulance!"
 "Mais, the phone don't work, no."
 "He's dead?"
 "Mais, no, he's still walkin' aroun'."
 "Where's the Chief?"
You put your catfish down.

 "Mais, who's that man on the groun'?"
 "That's the one who shot Dean, him!"

Sure enough, there's two big women sittin' on the shooter
He'll do no more shootin' tonight.

The police chief catches the catfish
That you're eating himself,
And he was at your table only minutes earlier,
 Calling you "Easy Money"
When someone in back said it was a perfect night for froggin'

And that was all it took.

Your guest the Welch poet from New York,
Scouting travel locations for the BBC
Is fascinated...wants a closer look.

But this is Henderson, and nothing is as it seems:
 The Chief is really frogging,
 But the bayou's not a bayou,
 And the phone is not a phone,
 And many a Professional Defender of Cajun Honor
 will sleep this one out.

You think it's all over,
But when you walk outside a half hour later...
You see
 Dean...
 sittin' in his car
 waitin' for the ambulance
 bleedin'

 "Mais, they wasn't drunk, no!"
 "Y'all back up an' make room for the ambulance!"
 "You think they got time to put it on the ten o'clock news?"

The Chief will be the last to know...
He's out froggin', him.

 Greg Guirard

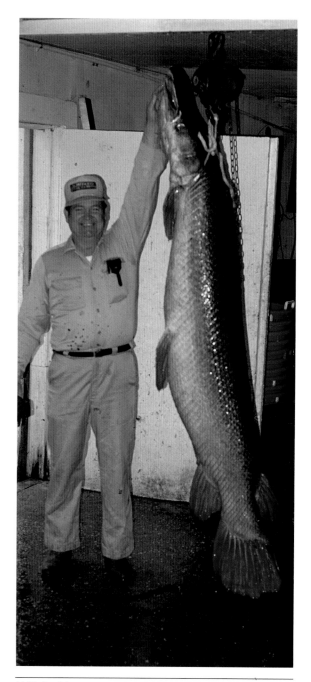

Wilvin Hayes and 201 lb. Alligator Gar from
Bayou Amy, Henderson, LA – 1991

"To Save a Giant" - from *The Land of Dead Giants*
by Greg Guirard - 1991

"I heard this story from some of the men who were there, and I believe that it is true," Aristile said to Alexson one fall day, as they chose a comfortable place to sit at the base of the big live oak in the front yard. They had been splitting and stacking firewood, and it was time for a rest and a good opportunity for Vieux Pop to share with Ti Frere one of his favorite memories. "Listen well, Ti Frere. This story may help you in more ways than one someday.

"There was once a stand of cypress trees even bigger than the others, on state land in Buffalo Swamp several miles south of here, and there was a crew cutting the trees for a lumber company. It was this time of year, if I remember correctly, yeah, mid-November, back in 1890. The water was low, the way it always is in the fall, and the crew had been working in that area for five or six weeks. Two good men could drop a tree of six or seven-foot diameter in about half an hour. The place was covered with the big logs, their tops and branches having been cut off by another crew. As soon as the river began to rise in December and flood the swamp, the logs would be floated out, gathered into rafts in the river and pulled to the sawmill.

"At that time logging crews lived in floating camps and didn't come out of the woods for weeks at a time; it was a rough life. One morning when the crew was nearing the end of its work in that area, they came upon a cypress tree that was considerably bigger and taller than all the rest—a giant among giants—and the men looked at it with wonder; none of them had ever seen a tree that size. They delayed cutting the tree, which was near the center of a small clearing in the swamp, purposely leaving it for last.

"Because it was not badly crowded by other trees, it had grown straight and tall, and its massive branches extended far out in all directions. Like many of the biggest trees, this one served as home for all kinds of birds and animals. Squirrels ran and jumped from branch to branch. Raccoons hid behind moss and leaves, peeking down on the men as they worked the saws and axes, always coming closer. Owls perched on the lower branches, watching qui-

etly. Hawks on the topmost branches looked over a scene totally unfamiliar to them—miles and miles of trees that had always towered to great heights above the swamp floor now lay flat and useless. Egrets and ibis came and went nervously, and songbirds with no other trees to land on filled the branches of this last tree. The air itself around the giant cypress was a swarm of birds and butterflies.

"As the time for cutting the big tree came closer, one of the men, Choupique LaCouture it was, began talking quietly to the others, out of hearing of the company boss, about an idea that had come to him earlier that day. 'You already saw a tree that big, you?' he asked one of the other loggers. 'Not me, no,' the man replied. 'Well, OK, then,' Choupique said, as if having reached a conclusion of some kind.

"Choupique had been injured the day before when a falling branch struck him on the right shoulder, causing a severe bruise. The boss had reluctantly given him a couple of days off to get well, and 'stop wasting company time,' as he put it. Choupique passed the time counting the annual rings on the stumps of fallen trees, trying to discover which of them had reached the greatest age.

"'Eight hundred and ninety-six,' he yelled from the top of an average-sized stump. Half an hour later he yelled again: 'One thousand four hundred and forty-seven!' An hour or so later he announced: 'One thousand six hundred and eighty-four!' Each time he found a new champion, the men would cheer and point to this or that stump, claiming that it could easily beat the current leader. Choupique would lie on his stomach with his head at the stump's center and begin counting. 'One hundred,' he would say, with his finger only a couple of inches from the center. Cypress trees standing so close together grew very slowly, and a hundred years of growth could be measured in only an inch or two of diameter," said Aristile. "'Two hundred,' he would announce a little later and further from the center. None of the other men would pay attention until he got over a thousand. Then they would begin betting a few nickels and dimes among themselves, as to whether a particular tree would beat the 1,684-year-old one, trying to judge, from Choupique's position on the trunk, how many rings might

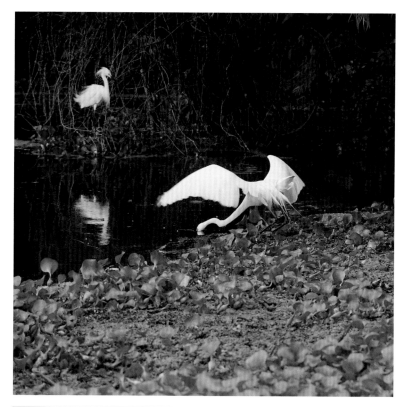
Snowy and Great Egrets Feeding near Butte LaRose –
October 1993

still remain to be counted. Just give Cajuns something to bet on, and they're as happy as a sac-a-lait in a school of minnows. Cajuns that don't like to bet are as rare as feathers on a catfish." Aristile smiled to himself.

"Some of the big trees were so close to one another that an agile man could sometimes jump from the springboard on one tree to the springboard on the next tree. The game was to see how many solid blows of an axe he could put into the second tree before the first one had finished falling and crashing into the shallow water around it, seeming to shake the entire earth. As soon as his partner would yell, ' Timber!' the springboard jumper, who never wore shoes, would grab his axe and leap for the nearest board, having chosen it beforehand. His axe would be flying toward the huge trunk even before he was safely perched on the board, and he would whack it as many times as he could while the first tree tottered and began to fall, its many

tons of solid wood speeding faster and faster toward the ground.

"As you can probably guess, Ti Frere, there were some quick bets made on how many axe blows the logger could make before the tree had completed its fall, and constant arguments about whether the tree had finished falling before or after the last axe blow. 'He hadn't even begun his swing,' one man would declare. 'Are you kidding?' another would ask. 'He was already pulling back for the next swing.' The record was seven blows; some said eight.

"Anyway, when all the biggest trees, except the one that stood alone, had been cut, Choupique found a stump nearby that had 1,829 annual rings."

"Vieux Pop," Ti Frere interrupted, "how do you know so many details about something that happened so long ago?" Aristile had gotten so wrapped up in his story, he nearly forgot, from time to time, that he was talking to Ti Frere. "And a little while ago, you said that Mister Choupique had an idea about something while he was counting the tree rings, but you never told me what it was."

Aristile ignored the question about knowing all the details. He shifted his position, watched a great egret spear a minnow in the shallow water across the bayou, and continued his story: "Choupique's idea was that the logging crew should not cut down the biggest tree. It was too beautiful, too big, too unusual. Felling it would be wrong, he thought, and the other men were ready to agree with him, but the lumber boss was not. It was his job to get as many logs to the mill as possible, and to leave the biggest tree out in the swamp was not something he would consider. But Choupique insisted: 'What's one tree?' he asked. 'Who's gonna know anyway? We already got thousands of logs ready to float to the mill.' The boss was not a man who was used to having his authority challenged, and Choupique was in danger of losing his job when one of the other men yelled, 'Lunch time,' and the problem was put aside for a while.

"The men walked to their pirogues and pulled out salt pork sandwiches that had been prepared for them that morning by the camp cook, and they sat on stumps to eat. Choupique and some of the others settled on the stump of

the 1,829-year-old tree, and Choupique began to count again, this time from the outside ring. 'O.K.,' he said, 'here we are—1890.' He made a mark on the outermost ring with the logger's pencil that he always carried, though the outside edge of the tree would have been mark enough. The other men, these cutters of ancient trees, looked on as though they had never before seen annual rings. Choupique counted back twenty-five rings and made a

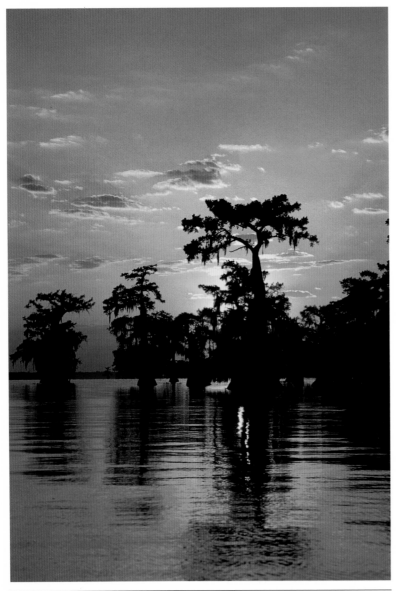

Summer Sunset at Lake Fausse Pointe – June 1995

mark: 'End of the Civil War, 1865,' he said. The two marks were less than an inch apart. He counted off sixty-five more rings and made a mark: 'Turn of the century, 1800.' He counted again and put a mark at 1765: '1765—the Acadians invade South Louisiana!' he announced. Some of the men laughed; others clapped and cheered.

"'Come ahead back,' Choupique told himself as he moved toward the tree's center, marking each century and historic date as he came to it. 1492 got an extra heavy mark. Most of the men had finished eating and some were napping briefly, waiting for the boss to order them back to work. The others counted silently along with Choupique, and watched as he made his mark for each century backward in time. Finally he said aloud, 'One thousand eight hundred and twenty-nine.' He took a scrap of yellowed paper from his pocket and did a calculation with his marking pencil. Then he put a finger on the exact center of the big tree's heart. 'I, Choupique LaCouture, am touching something today whose life began in the year 71 A.D.,' he said, and he left his finger there for several seconds, as if to gain something from the experience. No one else spoke nor moved. Even the birds in the big tree had gone silent. The stillness woke the two men who had been nodding off to sleep, and they raised themselves on their elbows and looked at Choupique. 'What's happening?' one of them asked. No one answered. Finally the boss spoke, and the spell was broken: 'Work time,' he said.

"Two or three of the men were still staring at the exact center of the big stump, and they found it difficult to move. One man picked up his axe and prepared to get down from the stump, but first he reached over and touched the place where Choupique's finger had been. '71 A.D.' he said. One after another, the men touched the spot, some in wonderment, others not wanting to miss whatever benefit might result. The boss laughed at the men: 'You Cajuns,' he said. 'Superstition starts just under your thick hides, doesn't it?'

"'Don't have nothing to do with being Cajun,' Choupique said. 'And as far as superstition goes, you don't know everything. Nobody knows everything.' Then he said something in French and turned away.

"The boss let the insult pass, since it had been spoken softly, and he could pretend that he hadn't heard it. Besides, he didn't want to have to admit that he couldn't speak their language to men who had learned to speak his, and he was eager to get the crew to work again.

"It was one of those cool, bright days in the fall, and Wilson knew that he could push the men much harder on a day like this than he could on the oppressively hot days of summer. He was ready to finish with the big tree and move on to destroy another part of the forest. Choupique wouldn't give up, though.

"'We been talkin' it over, Mr. Wilson, and we're gonna leave the big tree like it is,' Choupique said. At first, Wilson thought he had misunderstood. What he thought he had heard made so little sense that it confused him momentarily. But he made a speedy recovery: 'What did you say?' he asked. His disbelief was so thick you could have scraped it off by the pound with a dull axe." Aristile chuckled to himself.

"'I said we're gonna save this tree,' Choupique said, looking into Wilson's eyes without emotion or hesitation.

"'Don't believe I'm hearing well today,' Wilson remarked, sticking an index finger into each ear and shaking it, avoiding Choupique's eyes and smiling broadly at the other men, hoping that this was no more than a joke, and he could go on with the business of lumber production.

"But Choupique was determined: 'Look how much bigger this tree is than the one we were just sitting on. This tree was alive and growing when Jesus Christ was born.'

"'What of it?' Wilson said, 'He wasn't born out here in the damned swamp, was He? He wasn't born in the shade of this tree, was He?'

"'Not talkin' about where He was born,' Choupique said. 'Talkin' about when.'

"'I don't see the connection. This tree didn't know whether Jesus Christ was born or not and still don't know nothing about it to this day. Cut it down before I lose my temper.'

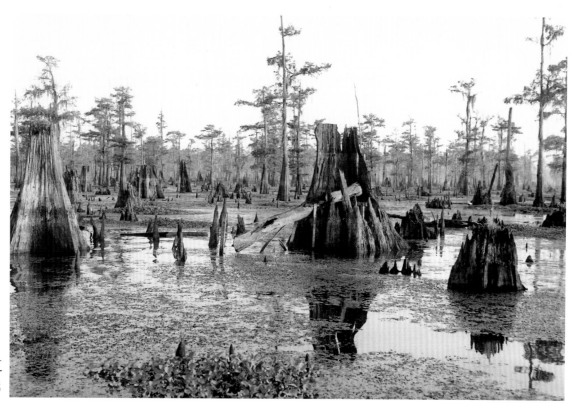

Stumps at Bayou Benoit, *Shy People* –
November 1986

"'How you know what a tree knows or don't know?' Choupique insisted, as Wilson began walking away.

"'You're fired, Lacucha!' he said, turning on Choupique. 'Pick up your stuff at the camp and move out! Lumber companies don't stay in business by leaving the biggest trees behind, and I don't stay in business by arguing with a bunch of ignorant swampers over whether or not to cut down a tree! The rest of you, get that damned tree down to my level, and I don't mean tomorrow evening!'

"The other men couldn't afford to be fired any more than Choupique could, so two of them walked up to the tree and began preparations to take it down. No one was moving fast, and Choupique hadn't moved at all. The two men at the tree avoided meeting his eyes. One began to sharpen his axe so that he could chop holes to support the springboards. The other began very slowly and deliberately to work on his crosscut saw with a file he always carried in his back pocket. Wilson pretended not to notice the delay. He sat on a nearby stump and began nervously to roll a cigarette. The rest of the crew stood around and watched. One man began to whittle on a wood chip with his pocket knife. Tension was high, and no one had the courage to break it by speaking. The only sound in the swamp was that of two files brushing steel, one on the axe, one on the saw. Finally, Wilson had had enough: 'You gonna chop them springboard holes, or you gonna work that axe bit till it's all filed away?' Choupique looked away from the tree. The man with the axe stepped up quickly to the ancient trunk, chose a location for the first hole and began his swing. The bit was a blur at the end of the powerful man's axe handle, but instead of biting into the sapwood of the big tree, it flew off and imbedded itself three inches deep in the stump where Wilson was sitting, missing his hand by an inch where it rested on the edge of the stump, the cigarette it held still unlit. All eyes were on the sharpened bit and the spared fingers next to it. Axe bits could fly off at any time, but these men were more careful than most, and no bit of theirs had ever left the handle.

"Wilson recovered quickly. To him nothing had meaning beyond itself. Not the strange silence, the men's crazy request, nor the flying bit had shaken him. He jumped down from the stump and said, to no one in particular, 'Give me an axe!'

"'Take mine,' Choupique offered, smiling as though he knew something that Wilson didn't.

"'Didn't I tell you to leave?' Wilson asked.

"'I want to see you cut down this tree first, Mr. Wilson, sir.' The silence was still so complete that the spoken exchange seemed unnaturally loud.

"Wilson grabbed the axe, spun on his boot heel and charged toward the tree. He tripped over a cypress knee and fell, and it was as he was starting to rise that lightning struck nearby and a deafening crack and a roar of thunder shook the ground and electrified the air itself. The men were stunned by the sudden noise and blinding light.

"Almost immediately a drenching rain began to fall, and everyone ran for whatever rain gear was stored in the nearby pirogues. Wilson stumbled again, this time at the base of the huge tree, and dropped the axe. Choupique stepped up and retrieved it, never once looking at Wilson, who by that time was soaked and shivering in the driving windstorm that accompanied the rain. Even the tree, in spite of its immense size, swayed a little in the powerful wind. Wilson realized that the men were leaving, going back to camp to escape the storm, and he knew that making them cut the tree down now would be impossible.

"Once they reassembled at the logging camp, not one man could remember having seen any buildup of clouds or wind before the storm hit, but in the heat and tension of the argument at the base of the giant cypress, the coming storm could have crept in unnoticed, they decided.

"Wilson had begun to fear the big tree, and whatever mysterious powers seemed to protect it, and he never returned to the Buffalo Swamp. When the water rose and the float crew entered the area that winter to collect the logs lying everywhere, they marvelled at the size of the lone cypress tree and at the axe bit stuck into the nearby stump. They gathered the logs into floating rafts, four to six logs wide and a hundred yards long, and began to move them by towboat toward the company sawmill near a little town on the western edge of the swamp.

"The story of the big tree and what happened there that day in 1890 circulated among crews in the logging camps throughout the Basin. No one could say with any certainty whether the occurrences on that day were the result of coincidence or of powers beyond human control, but there were many theories. Some people made the long trip into the depths of the swamp to see the tree and the axe head imbedded in the stump a few feet away. Some even put their hand where they thought Wilson's hand had been, near the steel bit, but no one tried to remove it, and it's probably still there now. Usually they would touch the big tree and then leave, and after a while people stopped going, the logging crews moved to other, distant stands of cypress, and the story was mostly forgotten."

"What happened to Mr. Choupique, Vieux Pop?"

"Well, he quit logging and went back to fishing for a couple of years, and then he moved away."

All I would have to say is, "The axe bit that nearly cut off Wilson's fingers was mine." I must be crazy to keep telling the boy about the old days and the big trees. The more I teach him to love my memory of what it was like, the more he will hate me for what I did. I can recognize the ghost of an old lie as well as any man, but I can't bring myself to tell him that I was a logger. I cannot be what I am not, until I am.

...

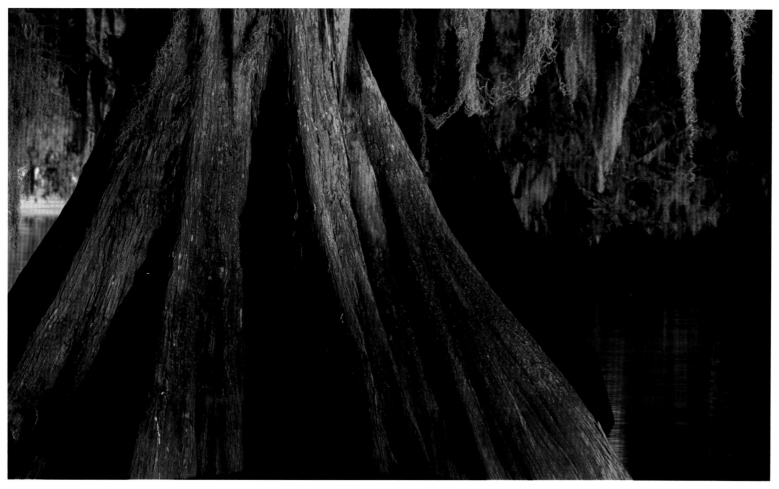

Cypress Tree with Spanish Moss at Lake Fausse Pointe – Early Morning, December 1994

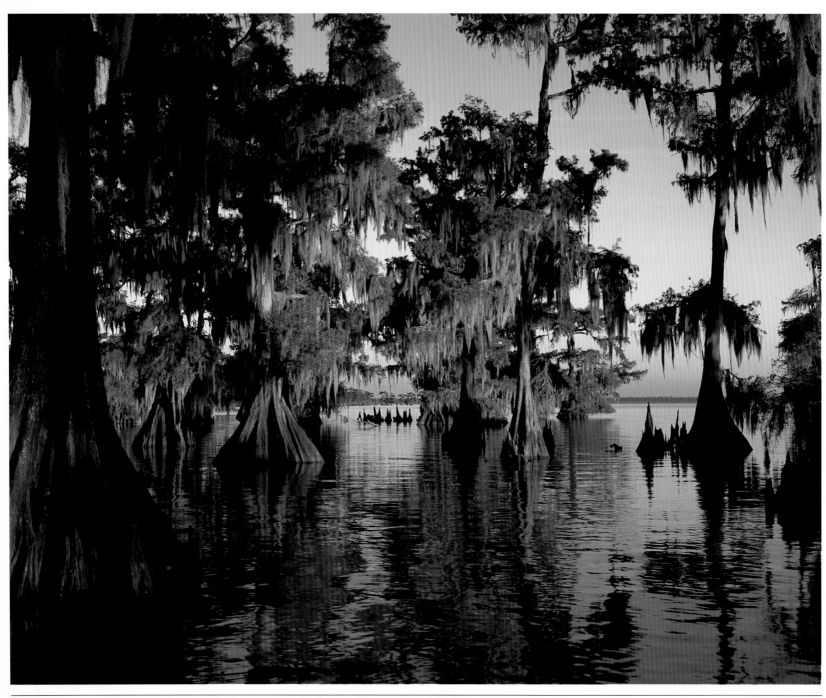

Late Afternoon from Platform at Lake Fausse Pointe – November 1994

"Reunion" - from *The Land of Dead Giants* - Greg Guirard, 1991

...Ti Frere had nearly finished his second sandwich and Vieux Pop was making some minor adjustments on his putt-putt motor when Aristile decided that there would be no better time to try to explain to Alexson what had happened when he had accepted work as a logger. He reached over and touched his grandson to get his attention: "Ti Frere," he began, "as a cutter of big trees I was very good—a champion. I was nearly as good with an axe as Lash Larue was with his long whip. I could drop a big tree and before it hit the ground, my sharp axe was biting into the next tree. I had jumped from one springboard to the next. We must do what we can do best in this life. Pride in cutting trees was one of my vines. I could have done something else...I know that now, but at that time, there was no one to uproot that vine and pull it off of me. Anyhow, I would not have let it happen. Not even Choupique could help me. I was twenty years old!

"I could have made boats, I could have made nets and caught fish and turtles as I do now. But cutting trees was what I wanted to do, and I was well paid by the land company. I thought I was something special. I didn't let myself feel anything for the great forest I was helping to destroy. All I could see were the trees that waited to be cut. I had no more understanding of what I was doing than a hound dog understands the deer he chases, so that the hunter can shoot it. If the dog does his work right, he is petted, praised and fed well. What does he care about the deer? If there comes a time when all the deer are killed, the dog will have to be trained to do something else. What about the people who wanted only to see the deer and to live in a world where deer could walk safely through ancient forests? As far as the dog is concerned, or the hunters, let those people visit the zoo."

Aristile filled his fuel tank from an old five-gallon can of gasoline he always kept under a canvas tarpaulin at the back of the boat...

"Do you pity the deer, Ti Frere, and the enchanted forest that has been converted into cutover swampland? Then pity me also," the old fisherman said, as he reached over and put his hand on the sleepy boy's shoulder. "I am a man who destroyed, with my own hands, the greatest and most beautiful thing I have ever seen with my own eyes."

...

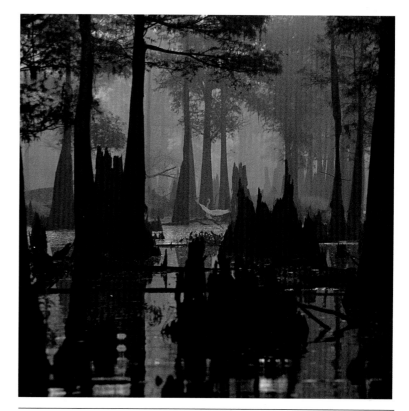

Great Egret at Sunrise near Bayou Benoit –
September 1980

97

LAKE FAUSSE POINTE – JANUARY 5, 1994
12:45 A.M.– Wednesday

Just woke up, as if by signal, and looked out the side windows to see a perfect half moon rising behind the cypress trees to the east, shaft of golden light on the water and all. I watched it from my bed. The flat part of the moon is almost horizontal, with a slight tilt to the south. I'm just realizing that the position of the curved part of the moon we see indicates where the sun is at this time, in relation to the moon. Hmmmm. Does this tell me that the sun will rise just to the north of where the moon is now? We shall see. This could help me set up a camera position before sunrise. I feel like the Mark Twain character in *Letters from the Earth* (was it Adam?) who had just discovered that water flows down-stream.

Two owls are calling in the woods to my left (west). I'll spend most of my daytime hours exploring those woods as well as the big trees along all the shorelines of the lake in a way I never have before–taking my time, stopping to look carefully, touching, seeing well. I've been here many times but always pretty much on a schedule, in a hurry. I've never spent nights and days here, just looking.

9 A.M.–I've been out to a place called Eagle Point for sunrise shots. The sun was a red ball when it cleared the horizon, but I was a little late setting up for it. Choppy waves may make my photos less than sharp. Tomorrow morning I'll set up on a stump or I'll be in the water with waders.

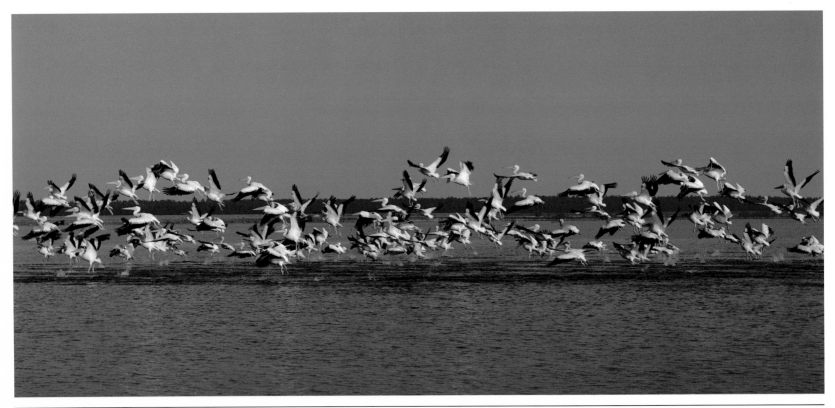

Pelicans Taking Off from Lake Fausse Pointe – December 1994

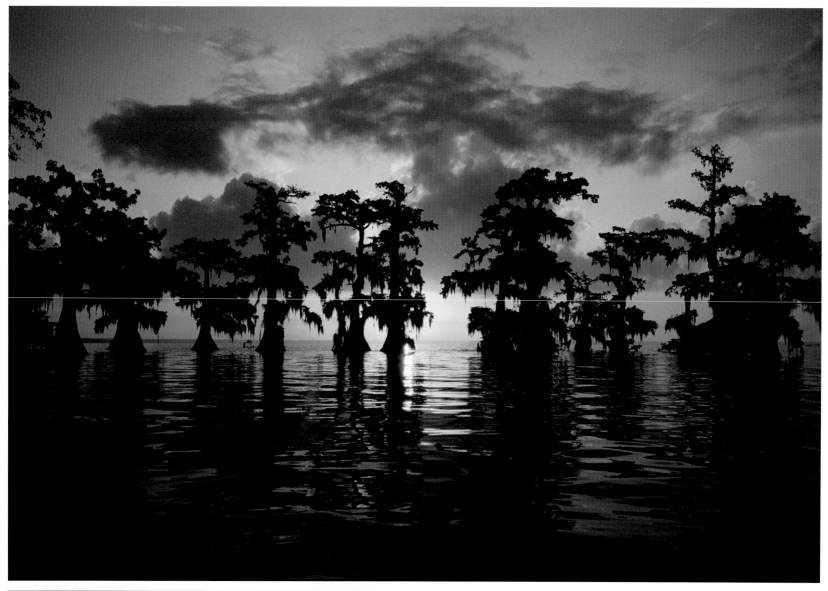

Sunrise at Eagle Point – January 1995

LAKE FAUSSE POINTE – DECEMBER 26, 1994 – Evening

....After sunset I travel the few hundred yards to the houseboat and begin to fix supper: cous-cous with sauce picante of rabbit, venison and pork sausage, biscuits with chicken and turkey jambalaya cooked inside, shrimp glacé, fried black beans and coffee.

I don't remember reading that any of the great writers consistently ate so much in the evening that they were too full to write anything worthwhile and had to retire to their beds before getting any work done, as I frequently do. They missed some fine times, some good meals, those writers.

CONCLUSION

I have my favorite places in the Atchafalaya Basin, and I take refuge in them over and over. I believe that I may see and understand more by spending 30 or 40 days and nights in one or two of these places than by spending the same amount of time in 30 or 40 different swamps. There's something about being out in the swamp, especially when you're alone, that seems to suck the poisons of civilization out of you–some sort of healing power in the air, the fog, the woods and waters, the tranquility, that melts the tensions and toxins of modern life right off and lets you begin to be yourself again.

Sometimes we try too hard to protect ourselves from discomforts that result from our encounters with the natural environment. Cold is to be avoided, and rain and wind. Why? How can we really experience the pleasure of warming ourselves at a blazing woodstove if we haven't come through an icy rain to get there? We soften ourselves and become dependent on the comforts that civilization provides. And in so doing we alienate ourselves a little more from Nature. We come to feel that the wilderness is a bit too harsh after all, so why should we concern ourselves with protecting it unchanged? We see that there is no need to rush ourselves with regard to caring for the natural environment. There's no apparent emergency here, so we become, or remain, complacent, apathetic. And the destruction continues.

Besides, we have faith in Science. We usually see science and technology as creative forces, helping us to solve problems. I find myself thinking of technology sometimes as a destructive force, an enemy of monstrous power, with a smiling face. Science can't fix a world out of balance.

We go along, as if half asleep, and then we are unaware of the consequences of what we've done until the moment before they arrive. My grandfather was able to tell me about the great trees, because he had seen them. I can't tell my grandchildren. My father's father was able to tell him about the clouds of passenger pigeons, because he saw them. I can't tell my children. I can tell my children about bayous through which I could travel by boat 40 years ago, and deep holes where I could always catch freshwater drum or catfish, bayous and deep holes that have been filled with sediment now. They can't tell their children. I can still say, "You should have seen the Atchafalaya when I was a boy," as my grandfather said to me. And they will say to their grandchildren, "You should have seen the Atchafalaya when I was a boy," but each time, with each passing generation, the reality of the Atchafalaya is an altered, diminished one. Where will it end? Nature is at our mercy.

If we could live a thousand years, we would see, at Buffalo Cove for example, a phenomenal swamp with cypress giants growing exceptionally close together, towering, massive....unless they are destroyed by sediment....or cut for lumber in an overpopulated world more starved for wood products than ever....or killed by air pollution or acid rain....

The big cypress trees are gone now, as well as the clearwater bayous and deep holes. They're no more likely to come back than the extinct passenger pigeons. Can science and technology reverse those losses?

I don't mean to sound overly pessimistic about the Atchafalaya Basin. In spite of my disappointment over the things that have happened there in the last 150 years, and even during my lifetime, it is the place where I feel most at home, where I find beauty, spiritual tranquility and true peace of mind. For me and for many others who have shared the Atchafalaya Basin experience, it's like no other place on earth.

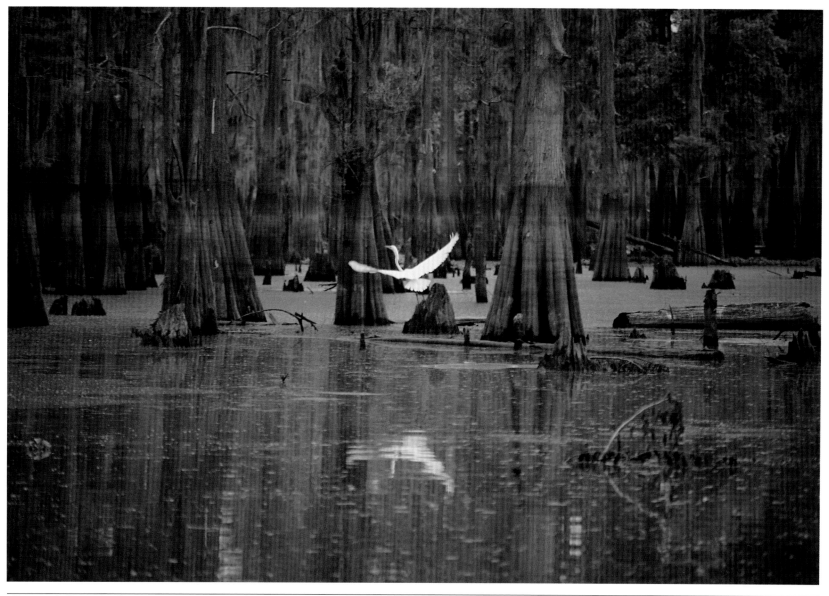

Second-Growth Cypress Trees with Great Egret at Buffalo Cove – October 1987

...to recognize some right the *earth itself* has that overrides the rights of people or society
to destroy it or to develop it or to progress, somehow, by diminishing it.

from LINES

....For I have learned
To look on nature, not as in the hour
Of thoughtless youth; but hearing oftentimes
The still, sad music of humanity,
Nor harsh nor grating, though of ample power
To chasten and subdue. And I have felt
A presence that disturbs me with the joy
Of elevated thoughts; a sense sublime,
Of something far more deeply interfused,
Whose dwelling is the light of setting suns,
And the round ocean and the living air,
And the blue sky, and in the mind of man;
A motion and a spirit, that impels
All thinking things, all objects of all thought,
And rolls through all things. Therefore am I
 still
A lover of the meadows and the woods,
And mountains; and of all that we behold
From this green earth; of all the mighty
 world
Of eye, and ear,–both what they half create,
And what perceive; well pleased to recognize
In nature and the language of the sense,
The anchor of my purest thoughts, the nurse,
The guide, the guardian of my heart, and
 soul
Of all my moral being.
....

William Wordsworth

from MY HEART LEAPS UP

My heart leaps up when I behold
 A rainbow in the sky:
So was it when my life began,
So is it now I am a man,
So be it when I shall grow old
 Or let me die!
....

William Wordsworth

Men say they know many things;
But lo! they have taken wings,–
The arts and sciences,
And a thousand appliances;
The wind that blows
Is all that any body knows.

Henry David Thoreau

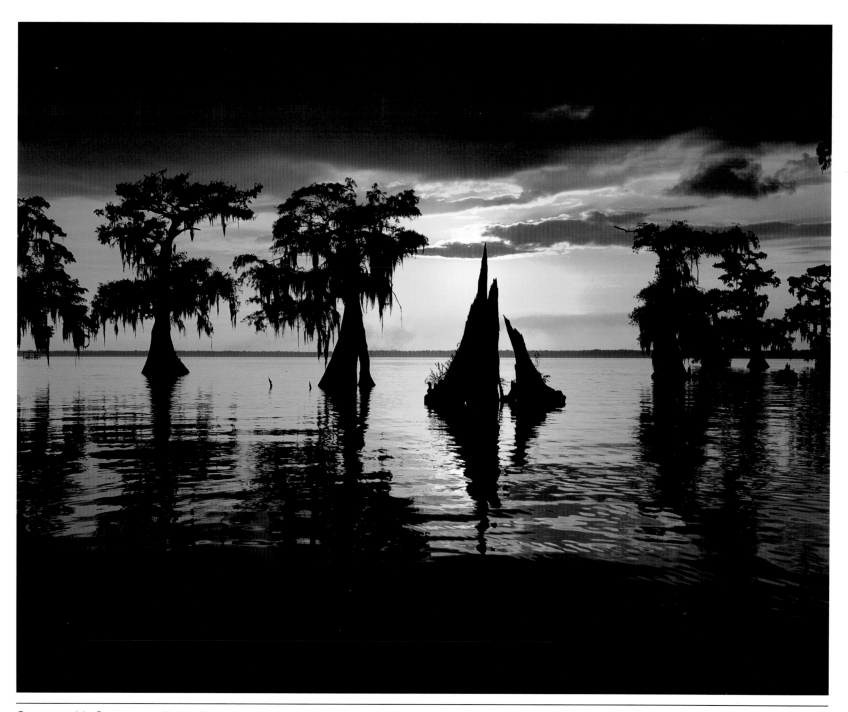

Sunset with Stumps at Lake Fausse Pointe – November 1994

Greg Guirard on His Platform, Lake Fausse Pointe – June 1995

Photo – Johanna Silverman

Works In Progress:

Inherit the Atchafalaya – writings and color photographs - 1997

Venerable Net Fishermen of the Atchafalaya – writings, interviews, and black and white photographs – 1997

The Land of Dead Giants – fiction in English with full Cajun French Translation and Compact Disc – 1996

Presently out-of-print:

Seasons of Light in the Atchafalaya Basin

Titles Still Available:

Cajun Families of the Atchafalaya

The Land of Dead Giants

Greg Guirard (318) 394-4631
1470-A Bayou Mercier Road
St. Martinville, Louisiana 70582